Salvador Dalí

A Mythology

D1337686

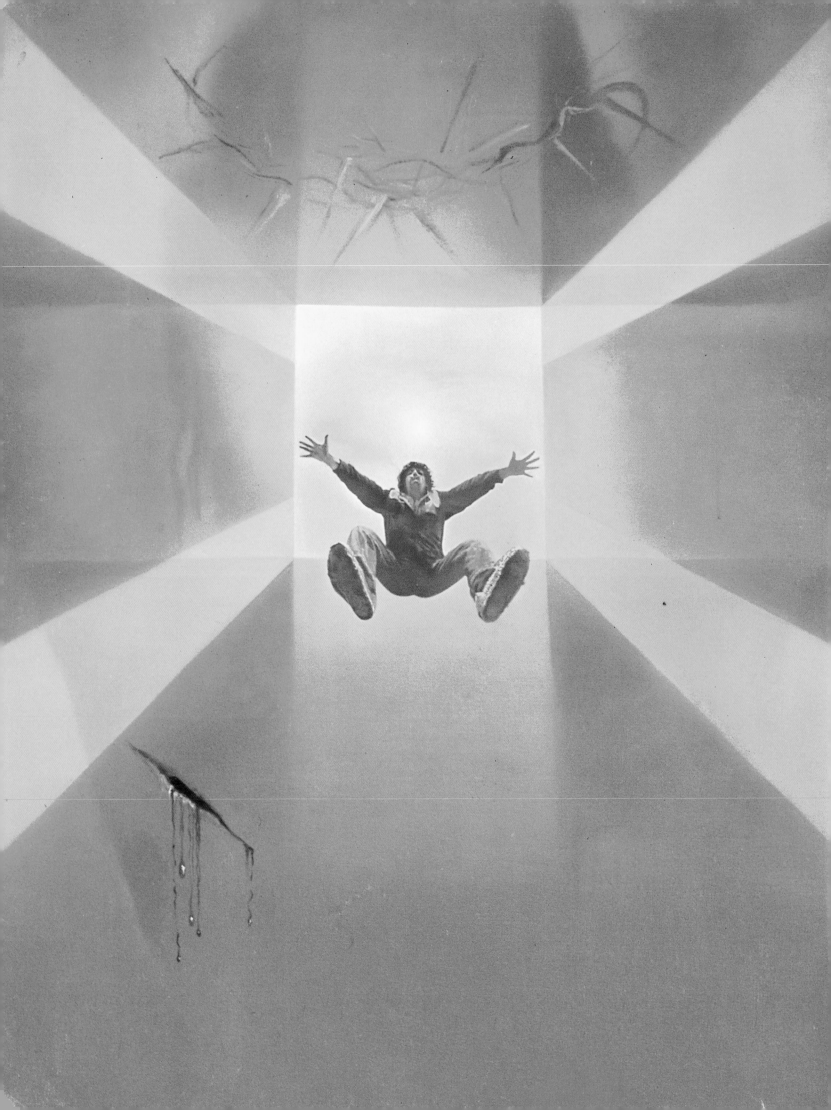

Salvador Dalí

A Mythology

Dawn Ades **Fiona Bradley**

Tate Gallery Publishing

This catalogue is published to accompany the exhibition
Salvador Dalí: A Mythology

Tate Gallery Liverpool
24 October 1998 – 31 January 1999

Salvador Dalí Museum, St Petersburg, Florida
5 March – 24 May 1999

Front cover
detail from **26** *Archaeological Reminiscence of Millet's Angelus* 1933–5
Salvador Dalí Museum, Inc., St Petersburgh, Florida

Back cover
31 *Couple with their Heads Full of Clouds* 1936
Museum Boijmans Van Beuningen, Rotterdam

ISBN 1 85437 259 9

A catalogue record for this publication is available from
the British Library

Published by order of the Trustees of the Tate Gallery 1998
by Tate Gallery Publishing Limited, Millbank, London SW1P 4RG

Copyright © Tate Gallery and the authors 1998

All works by Salvador Dalí © Foundation Gala-Salvador Dalí/DACS 1998;
works by Giorgo de Chirico © DACS 1998; works by Max Ernst and André
Masson © ADAGP, Paris and DACS, London 1998; work by Man Ray
© Man Ray Trust/ADAGP, Paris and DACS, London 1998; work by Pablo
Picasso © Succession Picasso/DACS 1998

Designed by Herman Lelie
Typeset by Stefania Bonelli
Production coordinated by Uwe Kraus GmbH
Printed in Italy

This publication is supported by
The Cultural Office of the Spanish Embassy, UK

Frontispiece
detail *Perpignan Railway Station* 1965
Museum Ludwig, Köln

Contents

Preface

Salvador Dalí is one of the most famous and influential artists of the twentieth century. Throughout his life he was an untiring self-publicist, and he fabricated an enigmatic public persona which has at times overshadowed his ability as an artist. His prodigious talent as a painter, film-maker, writer and draughtsman is often overlooked by art critics and historians. However, Dalí's oeuvre possesses a timeless appeal, replete with hidden messages and meanings. His energetic imagination and unique vision won him acceptance into the surrealist movement in the 1930s, and his paintings continue to fascinate subsequent generations. Countless books published on Salvador Dalí, the man and his work, testify to his unique status.

Tate Gallery Liverpool and the Salvador Dalí Museum St Petersburg are delighted to present this exhibition, which brings together a highly significant body of work. By focusing on a number of his pervasive themes, the exhibition aims to explain and 'de-code' some of the secret messages contained within the artist's oeuvre. By focusing on Dalí's engagement with myth, legend and religion the selection reveals how Dalí followed Sigmund Freud in appropriating certain age-old symbolic narratives and fables, embellishing them and adapting them to enrich the account of his own life. This remarkable act of egoism he achieved in both words and pictures. The paintings and drawings which have been selected date mainly from the 1930s, the decade in which Dalí created some of his finest works. However certain works of a later date demonstrate the consistency of his interest in mythological subjects.

The initial suggestion for the exhibition came from Fiona Bradley, Exhibitions Organiser at the Hayward Gallery and formerly Exhibitions Curator at Tate Gallery Liverpool. She and Dawn Ades of the University of Essex made the selection of works together, and both have contributed essays to this catalogue. Our thanks go to them, as well as David Lomas, Robert S. Lubar and Jennifer Mundy, who have all contributed essays of originality and insight to this publication. David Lomas's analysis of Dalí's famous painting *Metamorphosis of Narcissus* sheds new light on one of the great masterpieces in the Tate's collection, and provides us with a wider understanding of Dalí's relationship to Sigmund Freud. Robert S. Lubar's thought-provoking interpretation of Dalí's self-portraits offers insights into Dalí's encounter with another famous psychoanalyst, Jacques Lacan, Dawn Ades and Fiona Bradley examine Dalí's fascination with psychoanalysis and myth, while Jennifer Mundy's essay

offers a fascinating overview of the influence of mythology in art and literature preceding and pervading the interwar years.

This exhibition would not have been possible without the collaboration of the Salvador Dalí Museum in St Petersburg, Florida, which houses the collection of Mr and Mrs A. Reynolds Morse. This collection of more than 150 oil paintings, drawings and watercolours was built up over a period of many years, during which the Morses became Dalí's friends as well as his patron. Their collection is a lasting testimony to their faith in his genius and the significance of his oeuvre. The loan of so many valuable paintings and works on paper from the Museum is unprecedented, and it offers a unique opportunity to consider them alongside other major works from European and American collections. We are extremely grateful for the advice and support of all the staff at the Salvador Dalí Museum.

Thanks are due to all our other lenders – both public and private – who have parted with what is often a particularly cherished piece within a collection in order to participate in this exciting exhibition. We are particularly indebted to the Fundació Gala Salvador Dalí in Figueres, Spain for the loan of key works from their collection, as well as for the generous assistance provided by their staff with research for the exhibition in its initial stages. Important works have also been lent from the Museo Nacional Centro de Arte Reina Sofia in Madrid, and from the Tate's own collection. Special thanks should also go to Erica Davies, Director of the Freud Museum in London, whose enthusiasm and support for the exhibition has allowed us the opportunity to display an illuminating selection of material from Freud's collection, thus contextualising Dalí's fascination with Freudian psychoanalysis.

The realisation of the exhibition at Tate Gallery Liverpool was made possible through the generous sponsorship of Manchester Airport PLC and Tilney Investment Management. We would like also to offer our thanks to the staff at the Spanish Embassy, and in particular His Excellency the Spanish Ambassador, for their support of the exhibition, and their financial contribution towards the production of this publication.

Nicholas Serota
Director
Tate Gallery

T. Marshall Rousseau
Executive Director
Salvador Dalí Museum

Introduction

Dawn Ades and Fiona Bradley

Salvador Dalí was born in Figueres, Catalunya in 1904 and died there, in the theatre he had converted into a museum of his own work, in 1989. This loyalty to his birthplace and to the nearby Port Lligat, site of many of his paintings and the only place, he once said, he felt at home, is startling given the international scope of his reputation. Dalí is probably the most famous of all modern artists, and the most easily recognised thanks to his flamboyant personality and appearance. Well-educated, intelligent and in control, he used history, literature, religion, mythology, politics, contemporary science and psychology to construct a series of personae within which he could create his work, and in the context of which he could manipulate its reception. Mythology was central to these different personae; Dalí constructed its stories to reflect his own concerns, and also appropriated some of its systems and structures in his serial reinvention of himself. This book traces Dalí's fascination with myth in a series of readings of his paintings and writings, set against the wider background of a revival of interest in mythology and competing ideas about the absence or presence of a modern myth.

Dalí's construction of his own myth spread out to embrace myths drawn from the classical world and biblical history, which he both used with a directness unparalleled in other modern artists and recast to invest with meanings drawn from contemporary psychoanalysis: for instance Narcissus, Leda and the Swan, Abraham and Lot. History of a different kind – national or political, as with William Tell and Lenin, he drew into a mythological structure equally rooted in familial and sexual relationships. Dalí extended his myth-making to other objects, such as the popular devotional image of Millet's *Angelus*, over-riding traditional and sanctioned meanings to create his own interpretations. In doing so he underlined the mythical qualities of science, religion and psychology, centring them upon his own endlessly mobile persona.

Much of Dalí's work with his own identity took place within the surrealist movement, which he joined in 1929. Surrealism rejected the pragmatic, rationalist approach to life and art and, initially basing its ideas on Sigmund Freud's work on the unconscious, sought to revalue the dream and the imagination as central rather than marginal to human thought. Through their writings, poetry, the visual arts and in other ways, the surrealists blurred the boundaries between the rational and irrational, reality and fantasy, objective and subjective. Dalí was welcomed as a powerful new imagination: 'It is perhaps with Dalí that the windows of

the mind are opened fully wide for the first time,' proclaimed André Breton, the movement's leader, in his preface to the painter's first Paris exhibition in 1929.

The surrealist intellectual circles in which Dalí moved in Paris confirmed and extended the ideas he had formed as an art student in Madrid, alongside the poet Federico Garcia Lorca and the film maker Luis Buñuel. Here he had already encountered Freud whose *Interpretation of Dreams* he read shortly after its Spanish translation in 1925. As Jennifer Mundy discusses in the concluding essay in this book, an understanding of mythology as a repository of images through which to express profound and often repressed common aspects of the human psyche was fundamental to 1930s Surrealism. Surrealist writers, thinkers and artists were interested in the myths themselves and in their capacity, as revealed by Freud, the founder of psychoanalysis, to unlock the mysteries of the individual and the collective psyche. Dalí, however, was to construct his own lexicon of key myths: while other surrealists investigated the myth of Minotaur as metaphor of the labyrinth of the human unconscious, or myths of sacrifice such as Orpheus or Osiris, Dalí chose those that fed into his personal web of experience.

Another important contact for Dalí was the psychoanalyst Jacques Lacan, who was briefly associated with the surrealists in the early 1930s and published his essays in one of their journals, *Minotaure*. Lacan influenced Dalí's interest in the development of an individual's public and private personae. Lacan, whose work was based initially on a reading of Freud, gave Dalí an insight into the mobility of identity, constantly to be structured and restructured in response to encounters in the world. Dalí and Lacan shared an interest in the clinical condition of paranoia as a means of destabilising the interpretation of visual clues. Dalí's controlled simulation of paranoid vision led to the formation of his 'paranoiac critical method' and his famous double images – painted configurations which could be interpreted in two or more different ways. Based on the idea of a consistent delusional and irrational reading of phenomena by those suffering from 'paranoia', these images, like that of the *Metamorphosis of Narcissus,* were to become an important component of his unstable self presentation.

Dalí's first sustained use of simulated paranoiac perception to reinterpret an object whose identity was already conventionally established was his work with the *Angelus*, a nineteenth century painting by the French artist Jean-François Millet, representing two peasants joined in evening prayer. Dalí's book on this subject, *The Tragic Myth of Millet's 'Angelus'*, stands beside the great works of surrealist literature: Louis Aragon's *Paris Peasant*, Breton's *Nadja* and *L'Amour Fou*, as an example of their unique form of writing: neither fiction, nor autobiography, nor psychoanalytical case history but a mingling of all these into a 'living document'.

Dalí uses myth to code reality. His poetic and painted paternal and maternal imagos refer to his own mother and father, or to those who assumed this role in his emotional life, and it is invariably the relationship of both mother and father to son which is his prime concern. The first essay in this book traces Dalí's obsession with Millet's *Angelus*, his adoption of it as the illustration of a universal and tragic myth, his incorporation of it into his own painting and writing, and the way in which these create and express a persona. Identifying with the man of the couple in Millet's painting, Dalí recodified his position within his own family, his work turning around himself as both a lover and a son. Dalí's use of myth here is double-edged; in adopting for his own purposes an icon of the Christian religion like Millet's *Angelus*, and re-presenting it in a Freudian-inspired reading, he violently disrupts the ordered beliefs that underpin Millet's tranquil evocation of the call to evening prayer. His 'myth' penetrates and destroys the fixed Christian one, and in this sense takes its place within a surrealist reconstruction of the universe.

Although heavily coded and filtered through the forms and structures of myth, Dalí's fascination with the figure of the father begins with the reality of his own father and his relationship with him. The next essay in the book concentrates on Dalí's treatment of the paternal imago in various different myths, and their implications for his own identity. Instead of an invented myth like that of the *Angelus*, here Dalí calls on the great myth of Oedipus with its twin impulses of desire for the mother and murderous hatred of the father. Focusing on fathers triumphant rather than vanquished, Dalí sets up a sequence of relationships between himself as the son and the centre of his own myth and a variety of father figures; William Tell, Napoleon, Saturn, Lenin, and God.

Fathers are matched by mothers, and the following essay traces the development of the Dalinian persona in its dealings with the maternal and the eternal feminine: Leda, the Madonna and the surrealist and Freudian muse Gradiva. Again Dalí places himself at the centre of a network of relationships with the feminine, both as son and as lover, the female presence, primarily maternal, usually having the face of his wife Gala.

Dalí's exploration of relationships brings him repeatedly face to face with himself. David Lomas's discussion of his use of the myth of Narcissus is a sustained analysis of Dalí's presentation and manipulation of himself through the painting *Metamorphosis of Narcissus* and the poem that he wrote simultaneously, and intended to be read in conjunction with it. Dalí's masterly use of psychoanalytical ideas to explore the theme of the youth who fell in love with his own reflection and drowned trying to reach it brings in Freud's notion of the death drive, as well as conflicting homosexual and heterosexual impulses. David Lomas reveals Narcissus as a dangerous myth in the context of Surrealism's emphasis on *la femme*

aimée, and offers us Dalí as a knowing Narcissus, who draws Gala in as his own Narcissistic double.

Robert S. Lubar's essay on Dalí's self-portraiture looks at the ways in which self-portraiture in both writing and painting is in fact the subject and the object of his life's work. Dali's construction of identity stretches from some of his earliest paintings through his 'autobiography' *The Secret Life of Salvador Dalí* and is shown to be a brilliant performance, an endlessly re-invented myth of himself as artist.

In repeatedly turning to mythological subjects, whether those of the classical world or of his own invention, Dalí presents himself as a painter in quest of a stable identity which his engagement with Surrealism, and with the work of Freud and Lacan would have simultaneously shown him to be both elusive and illusory.

Dalí as Myth-Maker:
The Tragic Myth of Millet's *Angelus*

Fiona Bradley

Many of the ideas which underpin Salvador Dalí's work with myth, legend and belief may be traced back to his life-long fascination with the *Angelus*, a nineteenth-century painting by Jean-François Millet. This picture of a peasant couple called to evening prayer in the fields by the distant tolling of the Angelus bell, is one of the most famous and best-loved of all French paintings. It is endlessly reproduced and also has the distinction of having provoked an attack. Dalí recounts how a man, wanting to ruin the most famous painting in the Louvre, hesitated only momentarily before stabbing the *Angelus* in preference to either Watteau's *Embarkation for Cythera* or Leonardo's *Mona Lisa*.

Dalí was drawn to what he termed the 'mythic power' of Millet's picture. He wrote two texts about it: an article for the first issue of the surrealist journal *Minotaure* in April 1933, *Paranoiac-Critical Interpretations of the Obsessive Image of Millet's Angelus*; and a book written in 1938, lost, then found and published in 1963 as *The Tragic Myth of Millet's Angelus*. The texts explain Dalí's interest in the picture and his manipulation of it according to his own concerns, and are complemented and extended by a sequence of paintings beginning in the early 1930s and a series of illustrations for Lautreamont's *Les Chants de Maldoror* using the *Angelus*, from 1933–34. The paintings continued sporadically throughout Dalí's career as he returned to the theme, its elaboration encompassing ideas and stories from mythology, legend and the Catholic faith, and ultimately contributing to the great myth of Dalí himself.

> In June 1932, the image of the Angelus of Millet suddenly appeared in my mind without any recent recollection or conscious association to offer an immediate explanation. This image was composed of a very clear visual representation and was in colour. It was almost instantaneous and was not followed by other images. It left me with a profound impression, I was most upset by it, because, although in my vision of the aforementioned image everything 'corresponded' exactly to the reproductions that I knew of the picture, it nevertheless 'appeared to me' absolutely modified and charged with a such latent intentionality that the Angelus of Millet suddenly became for me the most troubling of pictorial works, the most enigmatic, the most dense, the richest in unconscious thought that had ever existed.[1]

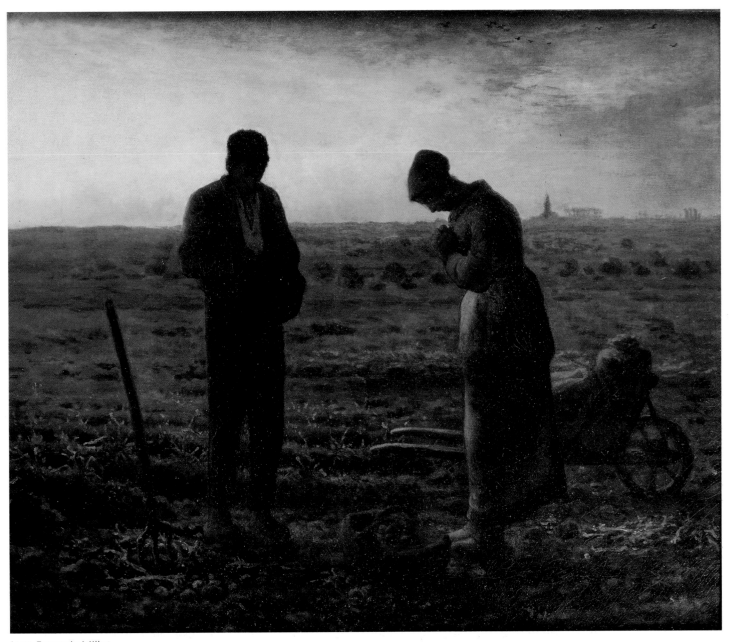

Jean-François Millet
The Angelus 1858–9
Musée d'Orsay, Paris

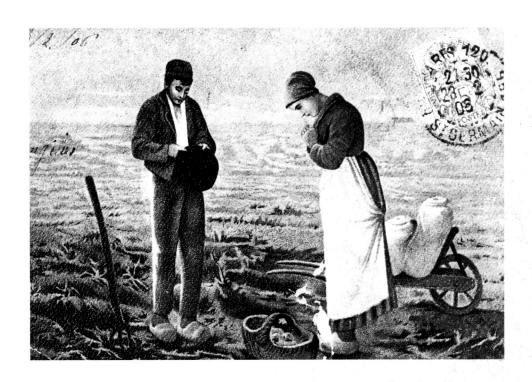

These illustrations from Dalí's book *The Tragic Myth of Millet's Angelus* demonstrate the artist's conviction of the pervasive power of Jean-François Millet's often – reproduced devotional picture. Dalí collected examples of it printed on cushion covers, ink wells and coffee services, wearing items from his collection to feature 'en Angelus' in the first and last images in his book.

Dalí's *Angelus* paintings, illustrations and texts are all apparently motivated by a desire to find out both why Millet's picture seems so rich in 'unconscious thoughts' and what exactly these thoughts might be. As he works with the *Angelus*, Dalí becomes convinced that the picture, like stories of Oedipus, Narcissus and the Holy Family, has a universal relevance and appeal, and may be used as a model with which to examine and explain patterns of individual and collective behaviour. Just as the Catholic Church uses Bible stories and the example of the Holy Family to structure a believer's understanding, and as Freudian psycho-analysis picks up on the older belief system of classical mythology to categorise a subject's psyche, so Dalí uses Millet's *Angelus*. His book *The Tragic Myth of Millet's Angelus*, written precisely like a Freudian case-history, maps the painting's complexities and makes a claim for its mythology.

In order to establish the *Angelus* as a potent myth and site of universal truth, Dalí first subjects the picture to his paranoiac-critical method. This method is essentially a system for the deliberate simulation of paranoid vision: the tendency to misinterpret visual clues and to 'see things' which are not really there. Dalí developed this method in the context of his work with Millet's *Angelus*, first calling his interest in simulated paranoia (suggested initially in his text *L'Ane Pourri* or 'The Rotten Donkey' of 1930) a 'method' in his essay on Millet's *Angelus* in *Minotaure*. Dalí, interested in contemporary research into paranoia, deliberately adopted a paranoid mode of vision as a way of re-reading objects or images whose meaning is conventionally accepted, in order to probe for a new, invariably surrealist and always Dalinian, meaning concealed within it.

In *The Tragic Myth of Millet's Angelus*, therefore, Dalí begins telling stories of encounters both real and imagined. He sees the *Angelus* couple reproduced on postcards, on coffee services, on tea cosies and cushion covers. He 'sees' them in pebbles on the beach, rocks in the volcanic formations of Cape Creus near his home, menhirs and bunches of cherries. Eventually, his cultivated obsession causes the sight of almost any paired object to engender an 'instantaneous flashing apparition of the Angelus'. With *Archaeological Reminiscence of Millet's Angelus*, the artist entices his viewers into a world of similarly *Angelus*-inspired paranoid vision. The painting offers a visual equivalent of Dalí's textual imaginings, as silhouettes of the *Angelus* couple are projected onto an image of ruined buildings. The painting asks viewers to recognise both ruins and figures at once, forcing us to share Dalí's belief in the visual or hallucinatory proof of the mythic potency of Millet's *Angelus*.

Having convinced himself of its mythic status through an analysis of its involuntary visual omnipresence, Dalí next attempts to unearth the key to its potency – the 'real' reason why

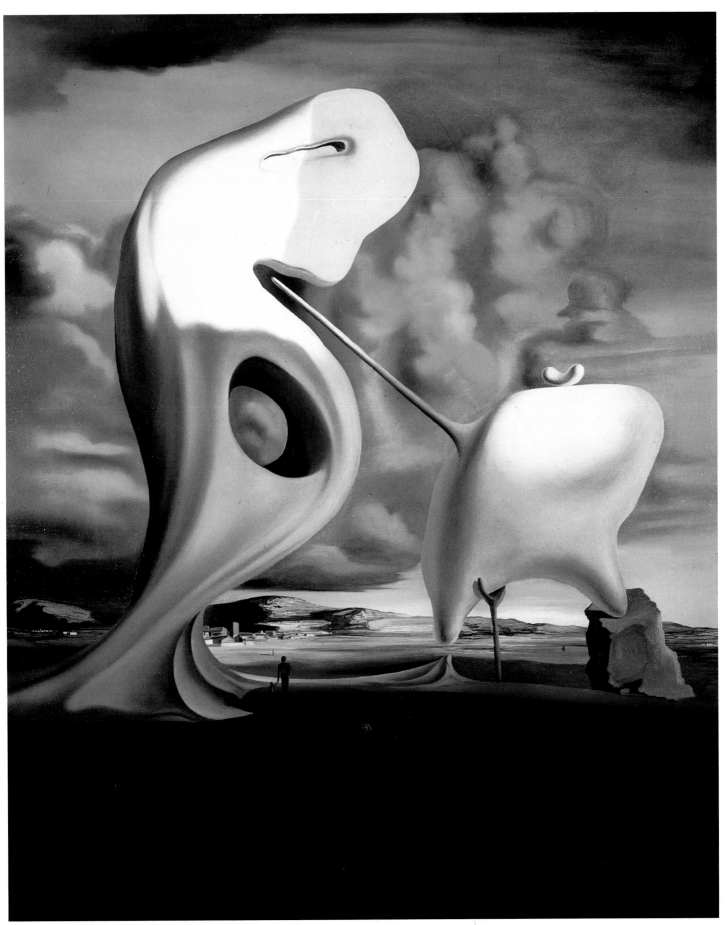

20 *The Architectonic Angelus of Millet* 1933
Museo Nacional Centro de Arte Reina Sofía, Madrid

the picture occupies such an important place in the French cultural consciousness. He begins in suitably Freudian terminology:

> The argumentative problem of the Angelus is resolved dream-wise. This is recognisable through the elements of 'condensation', 'substitution' and 'displacement' that permit and make possible the implicit existence in this painting of a vast subject with very differentiated, consecutive phases. It is all 'held' in an instantaneous image, which can be visually caught in a single glance, because it is exceptionally simple and apparently devoid of the least action. It remains for us to describe the successive phases of argumentative development constituting the myth.

The myth is, according to Dalí, one primarily dealing, like so many, with the universal constants of sex, death and family relationships. Dalí attributes the pervasiveness of the *Angelus* image to its secret enactment of an anguished family scenario, painted over by Millet in an attempt to make the picture more superficially appealing. Convinced that a tension greater than that of prayer crackles between the two peasant protagonists, Dalí imagines a third member of their family, a son, dead and buried in a grave concealed by the peasants' basket. The objective truth of this dead son is irrelevant to the elaboration of Dalí's argument, but he was nevertheless exultant when the painting was x-rayed and a plausible coffin shape was found in the underpainting of the area at the peasants' feet. This provided Dalí with an explanation for 'the inexplicable uneasiness of the two solitary figures, bound together in fact by the primordial argumentative element that is absent, "whisked away" as on the underside of a collage which one never sees'.

If the peasants' basket holds the clue to the atmosphere of death Dalí believed to be one fundamental part of the image's universal appeal, then their wheelbarrow is for him the first indication of another – sexual desire. Dalí subjects the wheelbarrow to a series of linguistic and visual paranoid associations:

> We know that peasants, in the rudeness of their labours, overwhelmed by physical fatigue, have a tendency to eroticise the tools that come to hand in a sort of 'atavistic cybernetic' way, the wheelbarrow being 'the supreme blinding phantasm' because of its anthropomorphic structure and its possibilities of functioning symbolically.

Establishing the wheelbarrow as a focus for sexual tension, Dalí can then paint its implications: *Perpignan Railway Station* makes explicit the wheelbarrow's true or at least Dalinian function in the 'rudeness' of nineteenth-century French peasant agriculture.

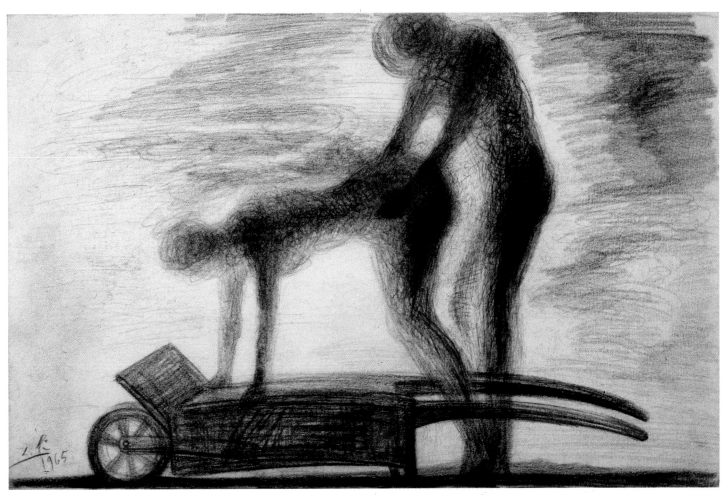

53 *Homage to Millet – Study for 'Perpignan Railway Station'* 1965
Fundació Gala-Salvador Dalí, Figueres

American 19th century cartoon. Frontispiece to Dalí's
The Tragic Myth of Millet's Angelus

Dalí's method of deliberately misreading the visual world led to the formulation of his famous double images – images constructed in such a way that they read convincingly as two different representations at once. In his work with Millet's *Angelus*, this allows Dalí to reference the mythological truth of the picture within his own versions of the peasant scene. In *Homage to the Angelus of Millet*, for example, Dalí draws the male peasant from a wheelbarrow, his knife-wielding partner's seemingly murderous intent perhaps actually an attempt at emasculation. That this was in Dalí's mind is confirmed by an American cartoon, inserted by the artist into the manuscript of *The Tragic Myth* immediately prior to its publication in 1963. The cartoon imagines a scenario in which a peasant woman castrates her man. The fear of such literal rather than simply figurative castration is later revealed to be at the heart of Dalí's own ambivalent attitude towards sex.

Throughout Dalí's paranoid reinterpretations of Millet's *Angelus*, both written and painted, the female peasant is the agent of sex and death who holds the key to the picture. Dalí sees in her pose, 'the immobility which is a prelude to imminent violence. It is also the classic attitude of animals about to spring, it is the one common to the kangaroo and to the boxer; especially that which is brilliantly illustrated by the praying mantis'. The mantis, beloved of Surrealism, famously eats her mate after and even during copulation – Millet's monstrous female, represented according to Dalí's interpretation of her in *The Architectonic Angelus of Millet*, also means harm to her man.

From the figures of the *Angelus*, their basket and their wheelbarrow, Dalí spins an elaborate story of sexual ambiguity, aggression and death. It has about it the familiar ring of the Oedipus story (son kills father and marries mother, ultimately coming to an unpleasant end) and is perhaps most chillingly represented in *Meditation on the Harp*. This painting temporarily resurrects the dead son, who intervenes in the relationship between his father and mother and embodies the death that is the inevitable male fate.

Dalí generally explores the competitive father/son relationship of the classical and Freudian Oedipal scenario via the legend of William Tell. He adapts the legend as a castration myth – the father who shoots an apple placed on top of his son's head is interpreted by Dalí as a father fearful for his own supremacy within the family, who symbolically castrates his son, rendering him terrified and impotent in the face of his own demonstrable competence. In Dalí's *Angelus* imagery, however, he shifts the balance of blame within the Oedipal story onto the mother, making the father and son almost interchangeable figures, both subject to the terrible power of the female. His William Tell imagery lingers in the repetition of the shape balanced like a target on the head of the male figure as he shrinks in relation to the female, and he links the female as Oedipal mother to the female as Oedipal sphinx:

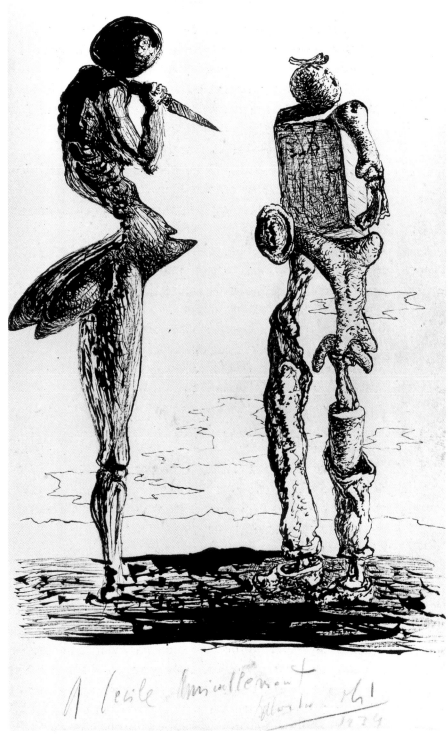

28 *Homage to the Angelus of Millet* 1934
Salvador Dalí Museum, Inc., St Petersburg, Florida

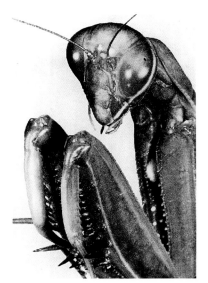

Praying Mantis. Illustration from
Dalí's *The Tragic Myth of Millet's
Angelus*

18 *Study for 'Meditation on the Harp'* 1932–33
Salvador Dalí Museum, Inc., St Petersburg, Florida

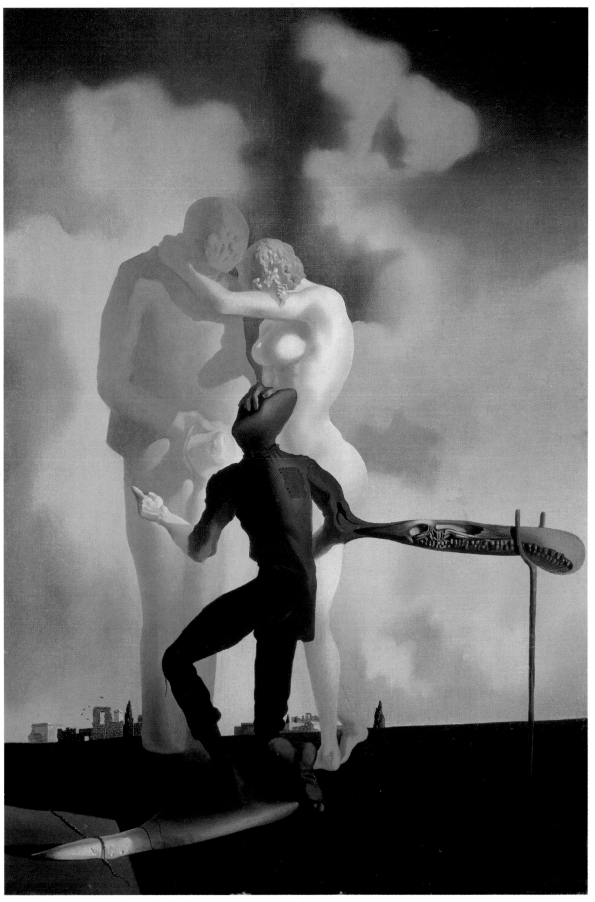

19 *Meditation on the Harp* 1932–34
Salvador Dalí Museum, Inc., St Petersburg, Florida

'the sphinx in whom each man interrogates his own anguish' is just part of 'the maternal variant of the grandiose, atrocious myth of Saturn, of Abraham, of the Eternal Father with Jesus Christ, and of William Tell himself – all devouring their own sons'.

In *Sugar Sphinx*, one of the most explicit of the *Angelus* paintings, the Sphinx is Gala, Dalí's wife, who stares at the Angelus couple in interrogatory confrontation. Her pose is echoed in *Perpignan Railway Station*, Dalí's most complete treatment of the Dalinian 'tragic myth' of Millet's *Angelus*, in which Gala (seated on a wheelbarrow) and Dalí compete along the vertical axis of the picture with the couple from the *Angelus* who stand along the horizontal axis. The two couples form a cross which marks the boundaries of a painting within which the latent and universally 'true' meaning of the tragic myth of Millet's *Angelus* (the sex implicit in the wheelbarrow and the death which is an inevitable consequence of this) is revealed in graphic, if shadowy detail: a sexual encounter between the two peasants is narrated either side of an image of the crucified Christ. At the very centre of the picture is another image of Dalí, twinned with Christ who represents not only death, but also the doubled father-son of the *Angelus* and Oedipal male – God the Father, God the Son.

This twinning of Dalí and Gala with the peasant couple from the *Angelus* confirms the extent to which Dalí's determined elaboration of the myth of Millet's *Angelus* is intimately involved with the creation of a myth of his own:

> I had a long reverie... in which I again saw, but this time with Gala as protagonist, certain exceptionally lyric moments of my adolescence in Madrid. I was visiting the Museum of Natural History with her just at sunset. Night fell prematurely in the vast and always rather sombre halls of the museum. In the very centre of the room displaying insects, one could not contemplate without fright the troubling couple from the 'Angelus' reproduced in sculpture of colossal dimensions. Upon leaving, I sodomised Gala in front of the very door of the museum, which, at this hour, was deserted.

Dalí explains that, in this fantasy, Gala takes the place of his mother, to whom he owes his terror of the sexual act and his belief that it would bring about his total annihilation: 'We would probably find at the origin of this terror a decisive and traumatic incident of exceptional savagery that happened in my earliest childhood and was directly related to the oedipus complex... a recollection or a "false recollection" of my mother sucking or devouring my penis'.

With these two false recollections Dalí identifies himself with the male *Angelus* peasant, and Gala – the mother – with the terrifying female. He establishes Millet's *Angelus* as the kind of

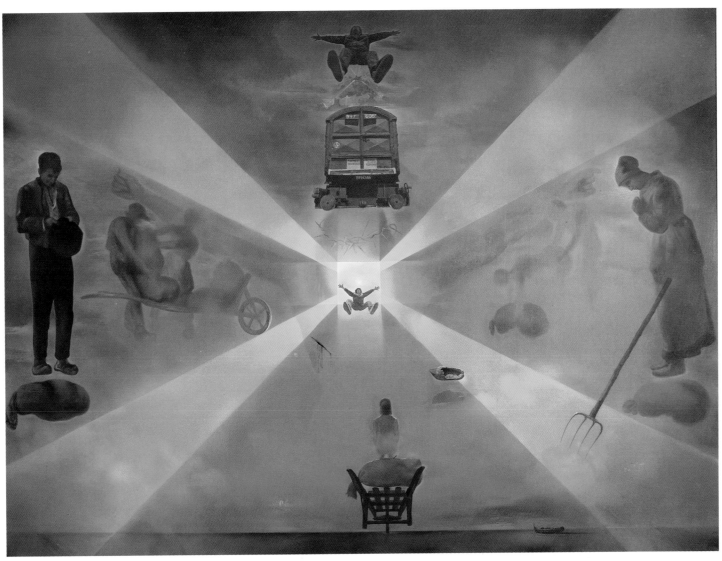

Perpignan Railway Station 1965
Museum Ludwig, Köln

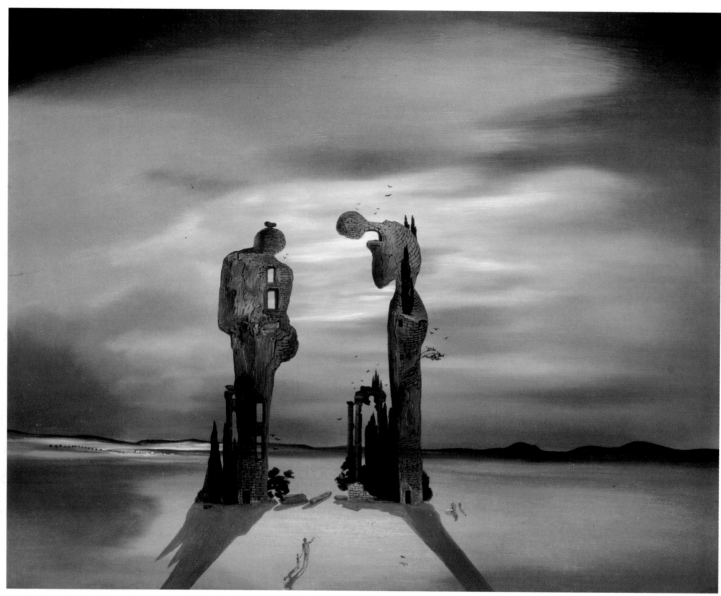

26 *Archaeological Reminiscence of Millet's Angelus* 1933–5
Salvador Dalí Museum, Inc., St Petersburg, Florida

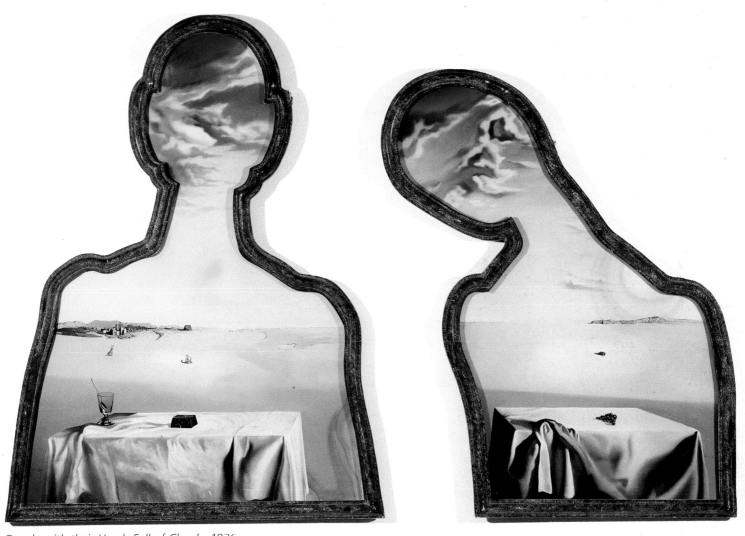

31 *Couple with their Heads Full of Clouds* 1936
Museum Boijmans Van Beuningen, Rotterdam

Portrait of himself with
girlfriend.
Their heads are full of clouds
their not living in the rest
world, their in love.
Their bodies are beaches
representing where they live
they live near the beach.
There is presence not yet
in mind!

myth which may be used as a model within which to interpret his own life, and adds Narcissus to the pantheon of figures – Saturn, Abraham, the Eternal Father, William Tell, Oedipus – whose mythic status underwrites the new truth of the *Angelus*.

Couple With their Heads Full of Clouds mimics the poses of the *Angelus* couple. Dalí identified this painting as a portrait of himself and Gala, and it is readable as a portrait of them as the couple from the Angelus. They are empty-headed (heads in the clouds as well as full of clouds, perhaps), their bodies a pair of beach scenes reminiscent of the often-painted beach close to Dalí's house at Port Lligat. Dalí and Gala posed for photographs with these figures, and Dalí reproduced them on the cover of his poem *Metamorphosis of Narcissus*. Both confirm the Narcissism at work in Dalí's treatment of the *Angelus* theme: the peasants become merely mythological types onto which Dalí can project his own preoccupations, primarily his preoccupation with his own persona.

This persona, deliberately constructed by Dalí through his painting and writing, is the myth which all other myths are used to create and sustain. One of the last *Angelus* pictures, *Portrait of my Dead Brother*, shapes out of cherries a composite portrait of Dalí and a brother also called Salvador who died before the painter was born. Dalí wrote that he and his dead brother were as alike as twins, as Castor and Pollux, the Dioscuri twins of classical mythology whose mother Leda was visited by Zeus in the form of a swan. The bird in this picture is not a swan but a vulture – both the 'maternal vulture' of the vengeful *Angelus* female, and the vulture which Freud, in his analysis of Leonardo's *Virgin and Saint Anne*, saw as the key to the artist's repressed fantasies and true subconscious personality. Dalí's personality is unrepressed, and is consciously constructed in the vocabulary of classical and Freudian mythology. The vulture hovering over the representation of the doubled Dalí and the liberated antics of the *Angelus* couple gives its tacit approval of Dalí's reinterpretation of Millet's *Angelus*, and of his application of it to the new myth of himself.

Note:

1
All quotations in the text are taken from Salvador Dalí, *The Tragic Myth of Millet's Angelus*, Paris 1963. In general, the translation relies upon that by Eleanor Reynolds Morse, in the edition published by the Salvador Dalí Museum, St Petersburg, Florida 1986.

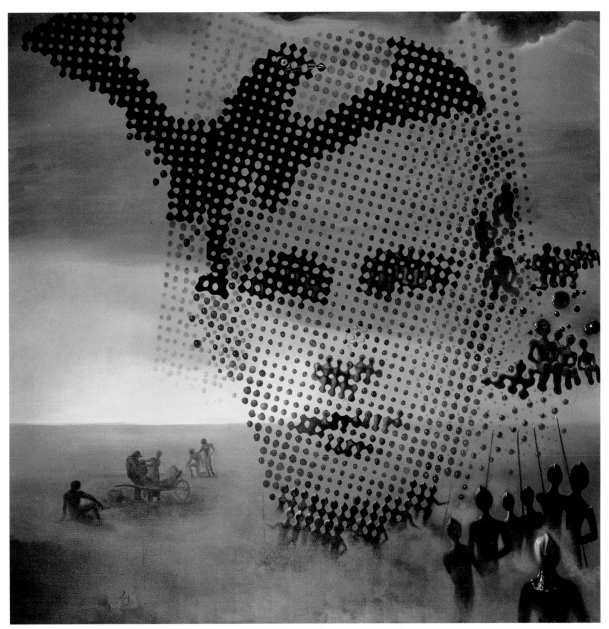

52 *Portrait of my Dead Brother* 1963
Salvador Dalí Museum, Inc., St Petersburg, Florida

The face in this composite portrait of Dalí and his brother (who died, aged 22 months, before the artist was born) is made up of hugely enlarged molecules, evidence of Dalí's enthusiasm for contemporary advances in molecular science. On close examination, however, the molecules are revealed to be pairs of cherries, their twinned similarity relating both to the obsessive kinship Dalí claimed to feel for his dead brother, and the artist's studied fascination with doubles and couples.

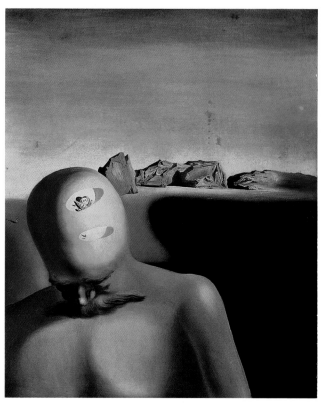

6 *The Average Bureaucrat* 1930
Salvador Dalí Museum, Inc., St Petersburg, Florida

23 *Study for 'Conic Anamorphosis'* 1933
Salvador Dalí Museum, Inc., St Petersburg, Florida

9 *Untitled* 1930
Mme Bénédicte Petit, Paris

27 *Conic Anamorphosis* 1934
Salvador Dalí Museum, Inc., St Petersburg, Florida

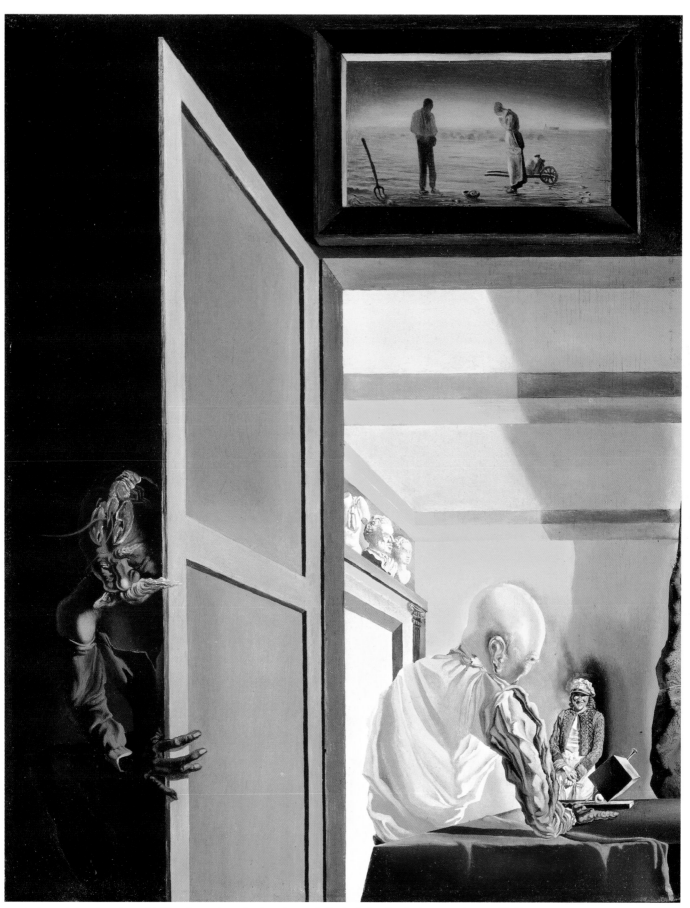

22 *Gala and the Angelus of Millet Preceding the Imminent Arrival of the Conic Anamorphoses* 1933
National Gallery of Canada, Ottawa

Dalí and the Myth of William Tell

Dawn Ades

Myths, as Levi-Strauss once said, are works of art[1] and like works of art their validity lies not in a simple factual truth but in their power to explain, to give form and meaning to human ideas and feelings. They may resolve contradictions in our social and economic settings, affective life or in our efforts to grapple with metaphysical enormities. In our era, following Sigmund Freud who, as Carl Jung pointed out, dusted off and brought to life again the ancient myths of Greece and Rome, they have taken on a new vitality as the bearers of psychological truths. For Freud, such truths are almost always sexual in origin, and the great myths like that of Oedipus have their origins deep in the human psyche. Thus Shakespeare's *Hamlet* 'has its roots in the same soil as Oedipus Rex',[2] that is the male's desire for his mother. The different treatment over time of the same psychological material serves to reveal profound changes 'in the mental life of these two widely separated epochs of civilisation: the secular advance of repression in the emotional life of mankind.' So in Oedipus, the child's 'wishful phantasy is brought out into the open and realised as it would be in a dream', while in Hamlet it remains repressed.

The other great myth is the death or killing of the father, which may be a complement or prelude to the Oedipus/Hamlet story, or may take centre stage in its own right (as, Freud suggests, in Dostoevsky's *The Brothers Karamazov*). This struggle between son and father may be reversed, giving us those stories in which the father threatens or conquers the son.

There is a poetic justice in the manner in which the term 'myth' is dismissed popularly as referring to mere 'fantasy', for the psychological truth of fantasies, and of dreams, has been overwhelmingly demonstrated not only on the level of an individual's private mental world but also in the wider contexts of whole peoples and nations. Myths are complex constructs of the human imagination, and as such often contain, like dreams, seemingly irrational or supernatural events and transformations. They may be susceptible to more than one interpretation, and may possess ambiguities which point to concealed conflicts and contradictions.

Powerful and persistent as the references are in Dalí's writings and paintings to a 'myth of the father', he never attempted a sustained analysis on this subject comparable to *The Tragic Myth of Millet's Angelus*. This extraordinary text, so precisely based on the structure of a Freudian psychoanalytical case study, discovered in Millet's 'insipid and stereotyped' picture

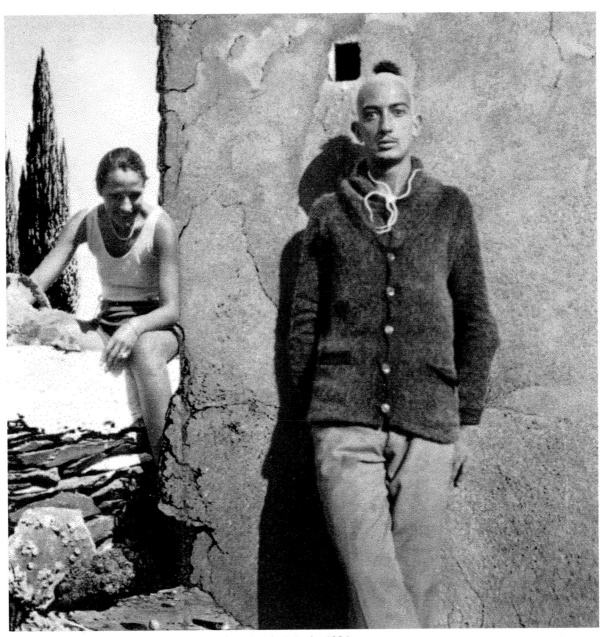

Frontispiece to Salvador Dalí, 'L'Amour et la mémoire', Paris, 1931
Fundació Gala-Salvador Dalí, Figueres

This photomontage juxtaposes Gala with Buñuel's
photograph of Dalí, taken at Cadaqués in 1929. The sea
urchin on Dali's shaved head is a deliberate echo of William
Tell, whose legendary feat of shooting an apple from his
son's head was interpreted by Dalí as a 'castration myth'.

15 *Figure after William Tell* 1932
Salvador Dalí Museum, Inc., St Petersburg,
Florida

16 *Figures after William Tell* 1932
Salvador Dalí Museum, Inc., St Petersburg,
Florida

42 *William Tell Group* 1942–3
Salvador Dalí Museum, Inc., St Petersburg,
Florida

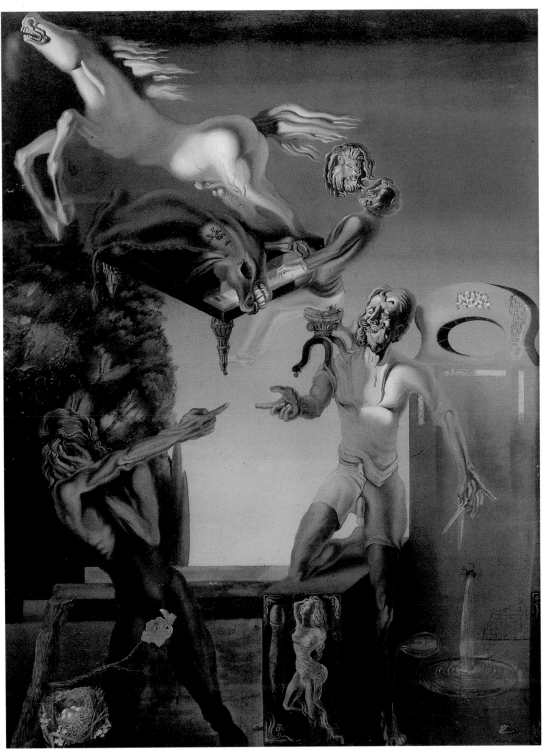

William Tell 1930
Private Collection

the 'maternal variant of the immense and atrocious myth of Saturn, Abraham, the Eternal Father with Jesus Christ and William Tell himself, devouring their own sons'.[3]

Whereas the Oedipus myth centres upon the successful revolt of the son and liaison with the mother, when Dalí focuses on the father figures, he chooses those who triumphed in their own myths: God, Saturn, William Tell, Lenin. As such, they are engaged by Dalí in the unfolding process of creating his own identity. The relations he sets up and manipulates between himself as the son and the centre of his own myth, and the father figures that appear in various guises in his paintings, are ambiguous in the extreme. They intersect with his sense of himself as artist, as sexual being and as member of a family. Whereas the 'maternal variant' has the Oedipal scenario at its core, the paternal version in Dalí's mythography is highly ambiguous in terms of sexuality. Although in writing he emphasises the vengeful and ritualistic fury of the father, there is a certain ambivalence in the paintings themselves which comes closer to the contradictions in his chosen myths. For with the possible exception of Saturn, the fathers are loving and sacrifice or prepare to sacrifice their sons unwillingly or in the interests of a higher good or higher power.

Dalí headed his 1952 text *The Myth of William Tell* with a quotation from Freud: 'he is a hero who rebels against paternal authority and conquers it'.[4] This is consistent with the rebellious attitude of the surrealists who identified in de Chirico's painting *The Child's Brain* the oppressive image of the father and of 'paternal authorities' like church and state. The English surrealist writer Robert Melville described the way that the Surrealists revealed for the first time the face of the father, object of their iconoclastic and revolutionary rage.[5] However, in Dalí's paintings the father-son relationship is manifested in different and sometimes conflicting scenarios: while the 'father' may be threatening and formidable, he also appears tender, or grotesque and even endowed with female breasts, the significance of which will be explored below. The son, meanwhile, is rarely the triumphant hero, but more often penitent or victim, hiding his face in shame or anguish.

The relationship to autobiography, and to Max Ernst's famous painting *Pietà or Revolution by Night*, a work of fundamental importance for Dalí, is interesting. This painting, together with *The Child's Brain*, established the iconography of a father figure as a modern personage (by comparison say with Blakean images of God the Father with flowing white beard). Ernst based his image on a type of late medieval South German sculpture which showed the dead Christ in the arms not of his mother as in the traditional Pieta, but of his Father. Christ, however, bears Ernst's features, and God the Father those that Ernst associated with his own father (the up-turned moustaches, for example).[6] The identity of the three figures in this painting has been much discussed, but of special relevance here is the proposal that

1 *Portrait of the Artist's Father* 1925
Museu Nacional d'Art de Catalunya, Barcelona

Max Ernst
Pietà or Revolution by Night
1923
Tate Gallery, London

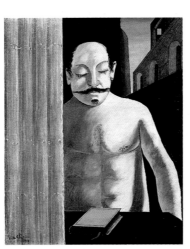

Giorgio de Chirico
The Child's Brain 1914
Moderna Museet Stockholm

2 *Portrait of the Artist's
Father and Sister* 1925
Museu Nacional d'Art de
Catalunya, Barcelona

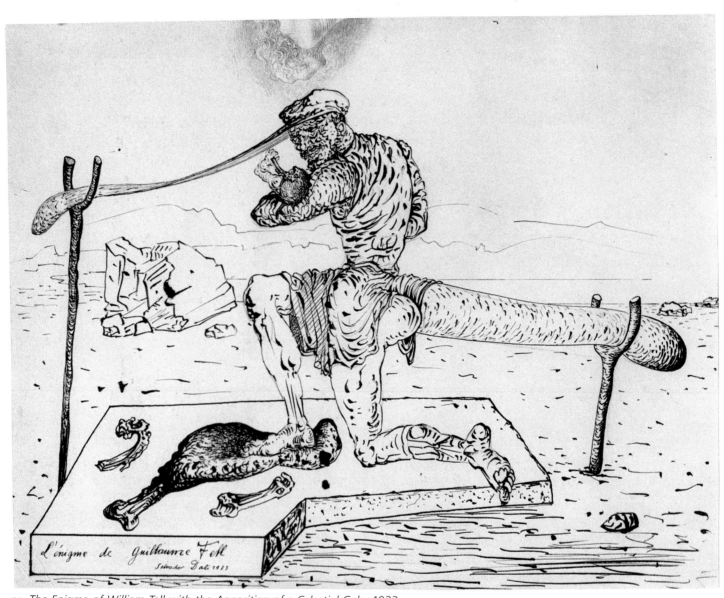

21 *The Enigma of William Tell with the Apparition of a Celestial Gala* 1933
Salvador Dalí Museum, Inc., St Petersburg, Florida

Ernst drew on one of Freud's case histories, in which a son's neurosis took the form of fantasies of himself as Christ, in which guise he was entitled to a physical closeness to a desired father.[7] But it is very hard to judge to what degree or purpose Ernst intended auto-biographical references, whether they were a consequence of his interest in Freud and psychoanalysis, whether his mood was ironic or confessional, whether this is indeed a 'dream image', or whether he intended primarily to shock.

Dalí visually models his father figure on the precedents of de Chirico and Ernst rather than on his own father's features. The bearded figures in his paintings of 1929 and after, however, vary considerably in age, and may even be meant to represent different incarnations of the mythical father. There is a strong resemblance between the bearded figures in *Illumined Pleasures* and *Accommodations of Desire*, for instance, and the bearded man with the bandaged head teetering on the stairs in Ernst's *Pietà*, who also bears a likeness to Freud which Dalí then enhances.[8] The only clearly recognisable historical character, though, whom Dalí depicts in this connection is Lenin; Napoleon is probably an allusion to Dalí himself.[9] In fact Dalí invariably separates, unlike Ernst, his painted self-portrait head from the 'sons' that he represents in various forms of engagement with the father, and their faces are almost always shielded or occluded, so that they cannot be identified.

In *The Myth of William Tell*, Dalí compares his own father with a Sophoclean tragic hero, and describes him as 'the man whom I not only most admired, but also most imitated...' A strong character, Dalí's father adored his son, and his belligerent non-conformism was itself a model for Dalí's iconoclastic behaviour. Dalí tells how he read assiduously the atheist books in his father's library and learned that God did not exist; he was thus profoundly shocked to read Nietszche and find the announcement of the death of God, as though he had indeed once been alive. Although feeling he had already moved beyond Nietszche, Dalí felt confirmed in his antisocial and antifamilial stance.

The mythical father of whom Dalí makes most pervasive use is William Tell,[10] and he began imaginatively to enact the myth before exploring the theme in his paintings, and in personally painful circumstances. In December 1929 he returned to his home town of Figueres after an exceptionally dramatic year which had brought acceptance into the surrealist group, a succesful exhibition in Paris, and a liaison with Gala, the wife of the surrealist poet Paul Eluard. This had transformed his own expectations as an artist, but had catastrophically upset those of his father.

A photograph of Dalí taken by Luis Buñuel at Cadaqués in December 1929 shows him with a sea urchin balanced on his shaved head, in place of the legendary apple. Dalí was

uncharacteristically reticent about the details of this incident. Although he describes in *The Secret Life* receiving a letter from his father, at this time, banishing him from his family, after which he shaved his hair off and buried it on the beach together with the empty shells of sea urchins he had just eaten, he nonetheless refused to unveil the secret that lay behind his father's anger, for it concerned 'only my father and myself'.[11]

Although one should beware of too simple a biographical interpretation of the imagery in his paintings it is evident, if only because of his silence, that Dalí's relationship with his father and their estrangement from 1929, was a powerful impetus to the visual and poetic elaborations of the William Tell myth. However, this was not exclusively the biological 'father-son' relationship: in *The Myth of William Tell*, Dalí identifies three Fathers who placed the 'apple of "cannibalistic" ambivalence on his head': his real father; André Breton, his new father on joining the surrealist movement; and Pablo Picasso – artistic father and rival.

What did Dalí mean by posing as the son of William Tell with the sea urchin on his head? Is his stance defiant, or is he enacting the expiatory sacrifice that lies at the heart of the myth of William Tell, Abraham or God the Father? Shaving the head could certainly be an act of contrition as well as traumatic abasement.[12] But the food on the head, from being the sign of the William Tell myth becomes for Dalí an alternative sacrificial offering: the sea urchin, his father's as well as his own favourite food, would tempt his father to eat it rather than him. The sea urchin is, moreover, eaten raw, and this Dalí saw, like Abraham's ram and William Tell's apple, as 'the prime condition for the cannibalistic sacrifice.'[13] In 1933 he painted Gala with two raw chops on her shoulder, which he interpreted to mean that instead of eating her he would eat the chops, and the idea of the diversionary offering is elaborated in another 'father' image, this time Lenin. In *The Enigma of William Tell*, Lenin holds in his arms a small child, whom Dalí identifies as himself, with a raw chop on his head, while the tiny walnut shell by his foot contains a defenceless Gala. The sinister gaze of Lenin ('he will look at me with a cannibal eye and I shall cry "He wants to eat me…!"'[14]) and the hugely elongated buttock-phallus make this a fearful father image, but there is still an ambivalence there in the gesture of cradling the child.

The father-son couples appear in a number of different guises, and as actors in various scenarios, not invariably that of William Tell. The significant presence of a paternal figure pre-dates the actual rift with his father, and from the start – in *The First Days of Spring* and *The Lugubrious Game*, which are the earliest in the sequence – is ambiguous on several levels. Unlike the earlier great images of the threatening father central to the surrealist imaginary – de Chirico's *The Child's Brain* and Ernst's *Pietà or Revolution by Night* – the surfaces of these paintings are scattered with numerous figures rather than a single central

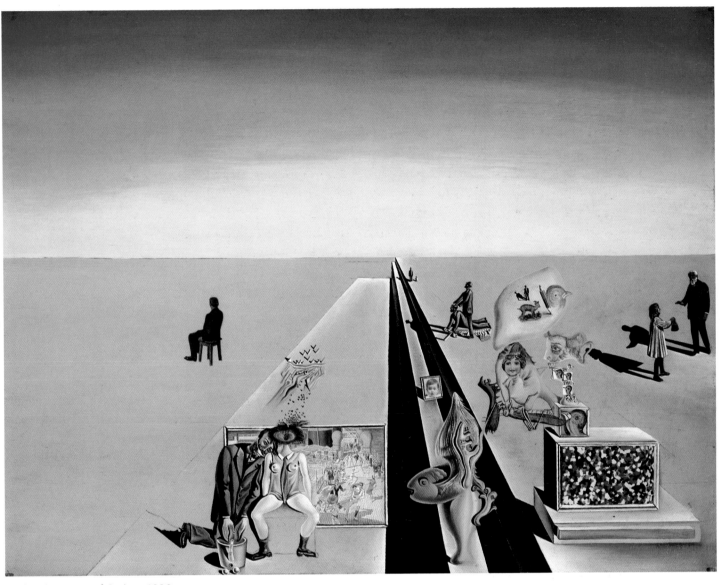

4 *The First Days of Spring* 1929
Salvador Dalí Museum, Inc., St Petersburg, Florida

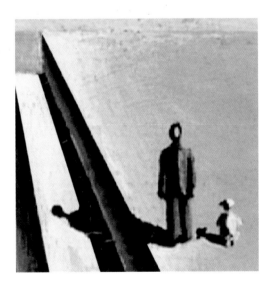

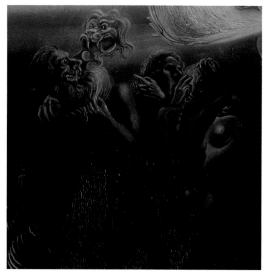

The Profanation of the Host 1929, detail
Salvador Dali Museum, Inc, St Petersburg, Florida

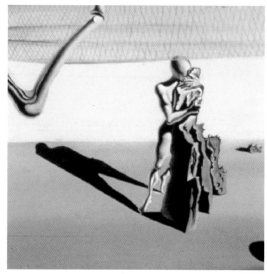

The Great Masturbator 1929, detail
Museo Nacional Centro de Arte Reina Sofía, Madrid

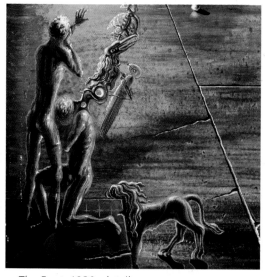

7 *The Font* 1930, detail
Salvador Dalí Museum, Inc., St Petersburg, Florida

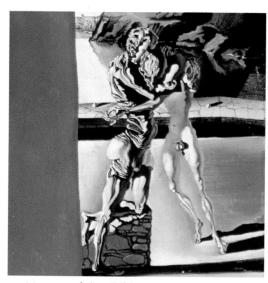

17 *Memory of the Child-Woman* 1932, detail
Salvador Dalí Museum, Inc., St Petersburg, Florida

An embracing couple, usually an older man and a youth, is a frequent motif in Dali's work. The gesture is often intense, suggesting either the anguish of William Tell, or the joy of the Prodigal Son's return. Sometimes the figures' nakedness or gestures point to sexual themes and to guilt. The gender may even be uncertain, as in the figure embracing an anthropomorphised rock in *The Great Masturbator*.

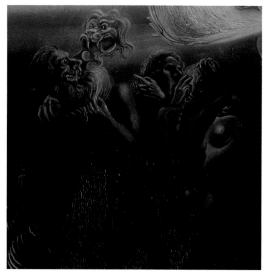

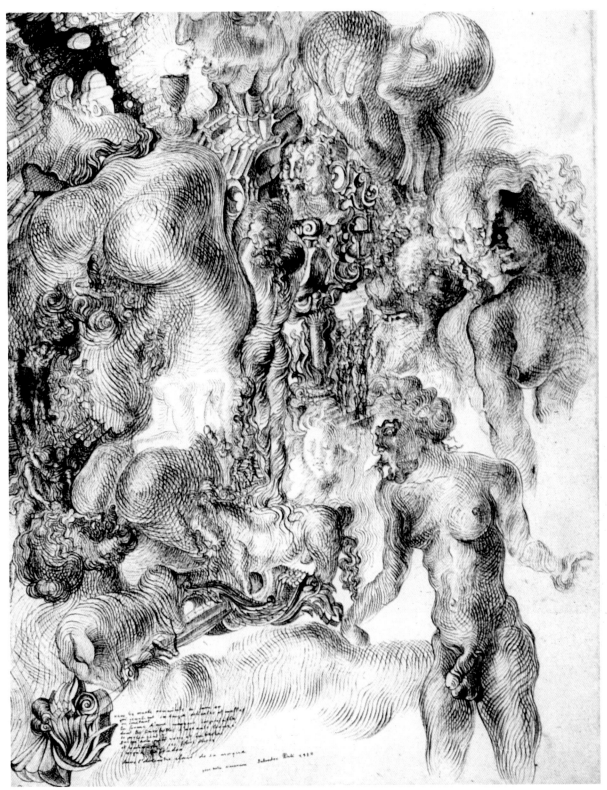

Frontispiece for 'La femme visible', Paris 1930

overpowering one. Apart from Dalí's own head, increasingly dissolving, most of these are cleanly delineated couples, often adult-youth or father-son, although the gender becomes increasingly ambivalent.

Among these pairs is the often minute depiction of a father and son as observers of the scene, frequently holding hands with the son dressed in a sailor suit. In *Imperial Monument to the Child-Woman* the father gestures to draw the child's attention to the figures of Millet's *Angelus*. They are like a nostalgic echo of childhood walks in the environs of Figueres and Cadaqués, when his father would point out fossils in the rocks, remembered by Dalí in *The Tragic Myth*.[15] Another recurring couple is that of the father and son locked in an embrace. In *The Lugubrious Game* the father and son to the right, despite the 'terrorising elements' of blood and excrement, are in a pose reminiscent of de Chirico's treatment of the Prodigal Son. This Biblical story, of the father's joyful welcome of a wastrel son, is in some ways the reverse of the 'atrocious' paternal myth Dalí explicitly invokes. This couple, and that on the left, a youthful pair who seem to be identical apart from the fact that the boy-sculpture on the pedestal is partly female, flank the central shattered form which has Dalí's horizontal portrait bust at the core. Both couples appear to be gripped by anxiety about masturbation and its consequences: the sculpture, who hides his face in shame, has an elongated hand while the old man in the foreground clutches a bloody object. The reference to castration is even clearer in the 1930 painting *William Tell*, where a bearded father figure triumphantly waves a pair of scissors, while the son hides his face, his genitals covered with leaves. The pointing fingers of father and son mimic the gesture of Michelangelo's God and Adam. Although Dalí never published his promised epic poem, 'William Tell', announced in *L'Amour et la mémoire* in 1931, the latter included long passages describing the terrifying figure of William Tell which resemble the painting: William Tell climbs a tree with jerky movements, his face contracted by a 'feeble and scornful smile that did not exclude hate, fury and disgust', his eyes 'furious and congested', his lower lip 'bitten until it bled ...', carrying a loaf of bread which he placed in a nest.[16] The dim figure of Gala/Gradiva in rococo relief on the end of the wall does not convince as the pretext or explanation of the scene: the drama is between father and son. While the implication of a violent attack on the son seems the core of the drama, the father's state of half-undress is also shocking; it recalls a strange, undated but surely very early drawing by the young Dalí which depicts a child in a sailor suit standing by a huge parental figure, clothed but with his penis exposed.[17] The sexualisation of son and father, both of whom moreover shift between male and female, seems to be derived from the paternal myth.

The bearded figure who appears in many drawings and paintings, sometimes specifically identified as William Tell, is in several instances, such as the frantic drawing used in *La*

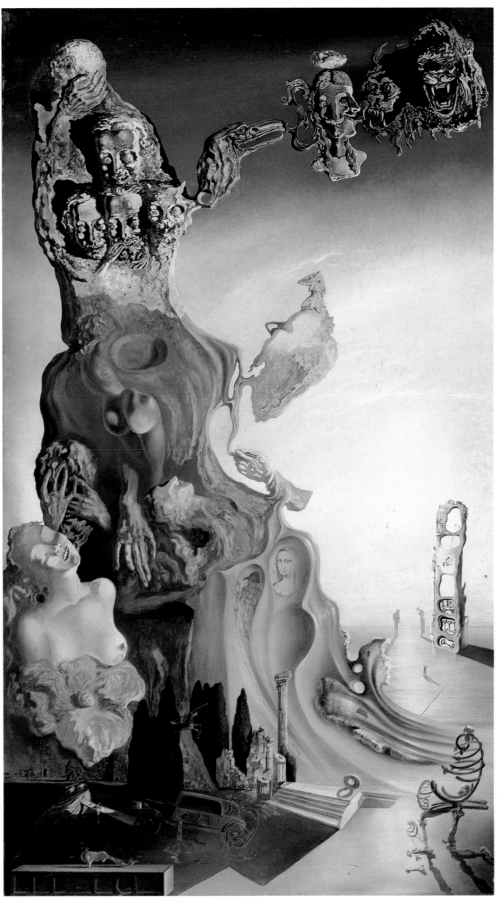

Imperial Monument to the Child-Woman c. 1929
Museo Nacional Centro de Arte Reina Sofía, Madrid

femme visible in 1930, and in the paintings *The Old Age of William Tell* and *Memory of the Child-Woman* endowed with breasts. Although this may be a reference to the prophet Tiresias, who had women's breasts, there is a more striking resemblance to an illustration in a manuscript by the seventeenth century painter Christoph Haizmann, which was the subject of Freud's paper, *A Seventeenth-Century Demonological Neurosis*. Haizmann's neurosis took the form of a belief that he had entered into a pact with the devil, whom he represented firstly as an 'honest citizen', and then in the shape of a mis-shapen man with breasts. Freud's analysis, which takes a similar track to that in the Schreber case, argues firstly that the devil is a father-substitute, and then that Haizmann's neurosis is the result of his repudiation of his 'feminine attitude' to his father. Freud outlines two explanations which 'compete with each other without being mutually exclusive':

> A boy's feminine attitude to his father undergoes repression as soon as he understands that his rivalry with a woman for his father's love has as a precondition the loss of his own male genitals – in other words, castration. Repudiation of the feminine attitude is thus the result of a revolt against castration. It regularly finds its strongest expression in the converse fantasy of castrating the father, of turning him into a woman. Thus the Devil's breasts would correspond to a projection of the subject's own femininity on to the father-substitute. The second explanation of these female additions to the Devil's body no longer has a hostile meaning but an affectionate one. It sees in the adoption of this shape an indication that the child's tender feelings towards his mother have been displaced onto his father; and this suggests that there has previously been a strong fixation on the mother, which, in its turn, is reponsible for part of the child's hostility towards his father...[18]

The complexity and contradictions in Dalí's various depictions of the father-son relationship have parallels with this analysis of conflicting emotional drives and their expression through repression and reversal. Whereas the evident sexual anxiety in Dalí's paintings has been interpreted in terms of a 'Scylla and Charybdis' scenario – sex with women and masturbation being equally fearful alternatives – this does not account for the gender changes in the paternal figure, nor for many of the father-son encounters and embraces (the Prodigal Son theme, for instance, and the highly ambivalent scene in the foreground of *The Font)*. The Haizmann picture and its reading by Freud comes closer to Dalí's imagery, which could thus at least in part be understood in terms of an 'unresolved conflict between a masculine and a feminine attitude (fear of castration and desire for castration)'.[19]

Other aspects of Dalí's treatment of the William Tell myth also support this idea: for example, the food (apple, sea urchin or chop) which he explained as 'diversionary' has undeniable

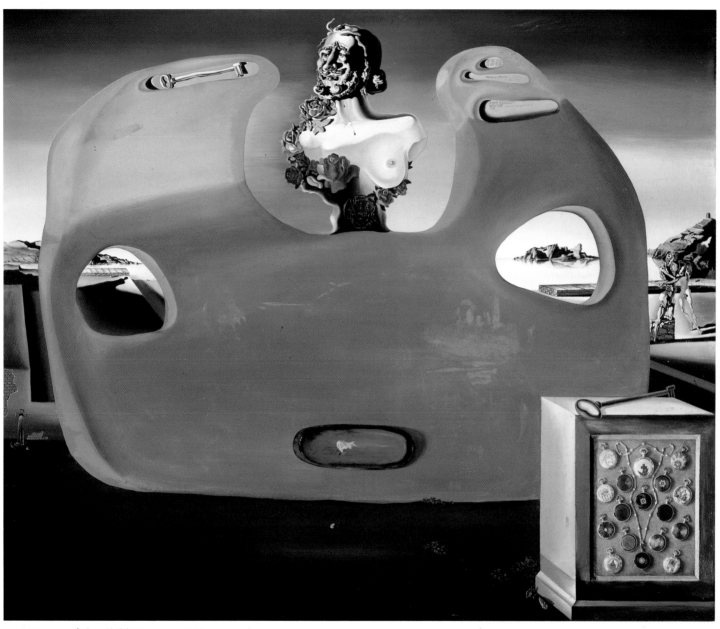

17 *Memory of the Child-Woman* 1932
Salvador Dalí Museum, Inc., St Petersburg,
Florida

Illustration from a manuscript by Christoph Haizmann

sexual connotations. When he announces 'I eat Gala', for instance, it is evidently a metaphor for sexual desire (with all its cannibalist undercurrents). Thus one could speculate that when Dalí had himself photographed with the sea urchin on his head, it was a symptom as much of desire as of fear of the father's attention.

We should never lose sight, though, of the gap between such readings of individual motifs in Dalí's paintings and their possibly symptomatic character, and a painting in its entirety. Combinations with other figures/motifs, the landscape setting, composition, medium, together with all manner of disjunctions of time and space, montage devices, metamorphoses and double images can change, complicate and supplement meanings. A painting is not, after all, a balance sheet. References may be delicate, occluded or private, and sometimes of a complexity that eludes any comprehensive overall reading. In *Memory of the Child-Woman*, for instance, a large ochre rock-shape is placed centrally against a coastal scene (probably one of the bays near Cap Creus, close to Dalí's home at Port Lligat), acting as pedestal and frame to the bust of the feminised William Tell. This rock with its holes and cavities has a long genealogy in Dalí's painting since 1929, including the huge central form in *The Great Masturbator* which amalgamates among other things the painter's own head, a rock, art nouveau architecture, and the similarly placed rock in *The Enigma of Desire (My Mother, My Mother, My Mother)*. As in the latter, there are minute inscriptions within the niches: 'ma mère' (my mother) is repeated ten times, and the symmetrical configuration of the holes gives an anthropomorphic, mask-like effect.[20] Dalí's own head is reduced to a tiny form in the sea-blue cavity at the base: a kind of self-abasement at the foot of the pedestal of William Tell; however, to the right in the background is an embracing couple: a youth clearly marked as male, clasped by an older figure. This figure is probably, again, William Tell, but the tight fitting drapery also hints at the female figures of this period, such as the one embracing an alarmed William Tell in *The Birth of Liquid Desires*.

In *The Old Age of William Tell* seduction, sacrifice and banishment are embodied in biblical references. A sheet (or a shroud) hides the lower part of several figures: in the centre, William Tell, again endowed with breasts, is flanked by two younger women. This suggests the Genesis story of Lot, who was saved from the destruction of Sodom and Gomorrah with his wife and two daughters. Because his wife defied God's commandment and looked back, she was turned into a pillar of salt. Lot lived with his daughters in a cave in the mountains, where, in order to ensure their succession and in the absence of other men they seduced him. To the left an uncannily doubled couple appear to be tethered to an altar, possibly invoking both the sacrifice of Abraham's son Isaac (a vestigial bush beside the altar hinting at the place where Abraham found the ram which he was able to sacrifice in Isaac's place) and Andromeda. The couple leaving in sorrow recall both Adam and Eve

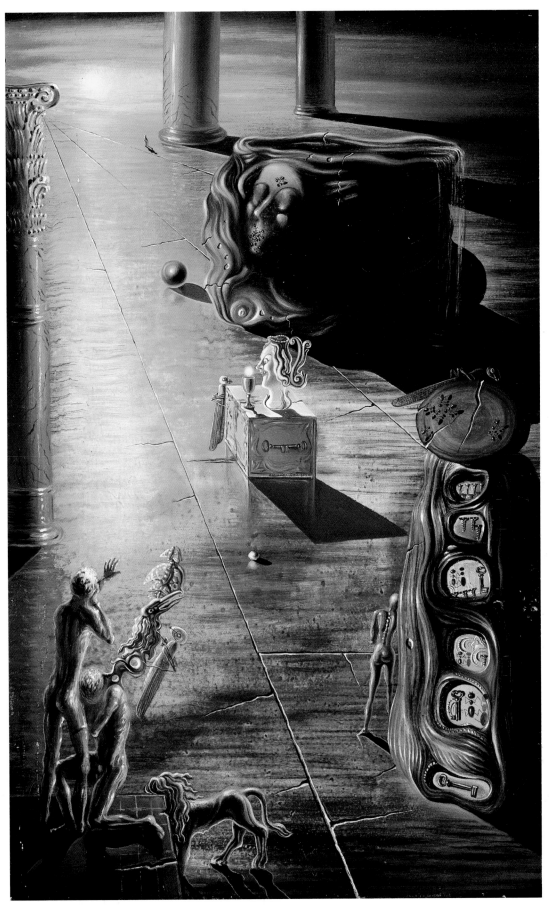

7 *The Font* 1930
Salvador Dalí Museum, Inc., St Petersburg, Florida

expelled from Paradise and Dalí's own recent experience of banishment from his parental home. The medallion of Napoleon refers to Dalí's own overarching ambition. At the extremes, then, of Dalí's creation of his own myth, and arising from his engagement with the contradictory myths of the father, lie the almost parthenogenetic hero-figure Napoleon and the self-abased and desiring victim-son of William Tell.

Notes

1
Claude Levi-Strauss, *The Way of Masks*, London 1983, p.14.

2
Sigmund Freud, *The Interpretation of Dreams*, London 1967, p.264.

3
Salvador Dalí, *The Tragic Myth of Millet's Angelus*, Paris 1963, p.89.

4
Salvador Dalí, 'Le Mythe de Guillaume Tell: Toute la Vérité sur Mon Expulsion du Groupe Surréaliste', lecture published by the University of Texas, 9 June 1952; without the title, this text comprised most of the diary entry for May 1952, published in *Journal d'un Génie* (La Table Ronde 1964; as *Diary of a Genius*, Picador 1976).

5
Robert Melville, 'Three Moves in the Big Game', *View*, Series 4, Autumn 1944, p.78.

6
Max Ernst, 'Visions de Demi-Sommeil' in *La Révolution Surréaliste*, nos. 9/10, October 1927; tr. in *Beyond Painting*, Wittenborn Schulz, New York 1948, p.3 (From Ernst's first 'Vision of Half-Sleep': 'From 5 to 7 years: a glossy black man is making gestures, slow, comical and, according to my memories of a very obscure epoch, joyously obscene. The rogue of a fellow wears the turned up moustaches of my father.').

7
Sigmund Freud, *Psychoanalytical Notes on an Autobiographical Account of a Case of Paranoia (Dementia Paranoides)*, Schreber, 1911, Pelican Freud Library, vol.9, Case Histories. For interpretations of this painting and identifications of the three figures see Malcolm Gee, 'Max Ernst, God and Revolution by Night', *Arts Magazine*, no. 55, 1981, p.85–91; Dawn Ades, 'Between Dada and Surrealism: Painting in the Mouvement Flou', in *The Mind's Eye: Dada and Surrealism*, ed. T. Neff, Chicago 1984, p.23–41; William Camfield, '*Max Ernst, Dada and the Dawn of Surrealism*, Menil Collection/Prestel 1993, p.138.

8
See note 7 above. Two not incompatible identifications of the three figures in the Pietà are 1) Max Ernst, his father and Freud, and 2) (bearing in mind that they form a Trinity) Father, Son and Holy Ghost.

9
Dalí mentions his ambition to be Napoleon at the beginning of *The Secret Life*. I do not think Dalí's references to Hitler, which caused him such grief with the surrealists, constitute Hitler as a father figure; he is quite explicit on Hitler's femininity, without the tensions exposed by the sexuality of the powerful father William Tell: 'Hitler... always appeared to me as a woman' (*Diary of a Genius*, op. cit., p. 27).

10
William Tell was reputedly a Swiss patriot who resisted the Austrian occupying powers of his native Canton of Uri in the early 14th century, and initiated the movement that led to the independence of Switzerland. For refusing to bow to the ducal hat, he was condemned to shoot an arrow through an apple on his son's head. His authenticity, like that of Robin Hood, has been questioned, given the existence of many stories of stupendous marksmen in folkore. The mythic significance of William Tell would normally encompass ideas of resistance to the invader, national freedom and patriotism – as in the epic drama by the prominent Catalan writer Eugenio d'Ors. Dalí's annexation of the story for a very different type of myth may not be unconnected to some rivalry with d'Ors; moreover, the debasement of a political leader in however devious a manner is not inconsistent with the revolt against paternal authority.

11
Salvador Dalí, *The Secret Life of Salvador Dalí*, p.253: The causes of the rift which have subsequently emerged are multiple, but the most serious beside his father's suspicion of the surrealists' decadence, and disapproval of Gala as a married woman, was the blasphemous inscription on a 1929 painting: 'Parfois je crache par plaisir sur le portrait de ma mère' (sometimes I spit with pleasure on the portrait of my mother). Dalí's father was unaware as is clear from his letter to Lorca about the affair that the mother in question was not Dalí's but the Holy Mother or Virgin Mary (See Ian Gibson, *The Shameful Life of Salvador Dalí*, London 1997, p.239). Dalí's painting depicts the outline of Jesus Christ with hand raised in blessing; given however, Dalí's known fascination with Ernst's *Pietà*, it is possible that there was an underlying hint of a blasphemous self-portrait, in which case Dalí's father was not so far from the mark after all.

12
Ian Gibson (op. cit., p.240) suggests he cut off his hair to symbolise the start of a new life.

13
The Secret Life, op. cit., p.319.

14
ibid.

15
Salvador Dalí, *The Tragic Myth of Millet's Angelus*, op. cit., p.59. Fossils had deep significance for Dalí; his father had one on his desk which exactly recalled the female genitals.

16
Salvador Dalí, 'L'Amour et la Mémoire', *Editions Surréalistes*, Paris, 1941, p.23 and 25.

17
The drawing is in the Perrot-Moore Arts Centre in Cadaqués, Spain.

18
Sigmund Freud, *A Seventeenth-Century Demonological Neurosis* (1923), Pelican Freud Library, vol.14, Art and Literature, p.405.

19
ibid., p.407.

20
The inscriptions read, from the top: ma mère repeated 10 times; Fantasies diurnes; then grand chienalie chanasie/ Le grand masturbateur/ Guilaaume Tell/Olivette/Olivette/Olivette/ concretion nostalgique d'un cle.

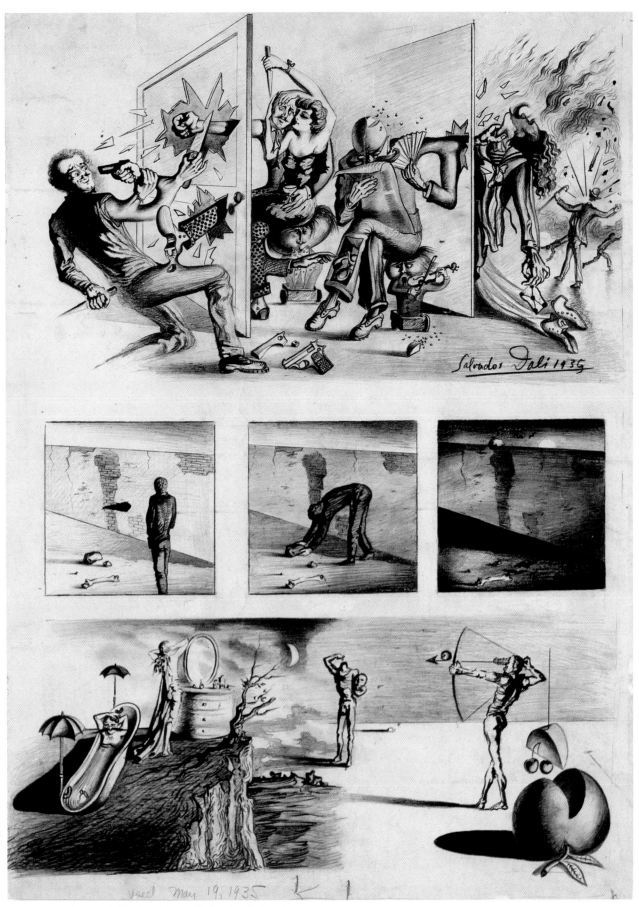

30 *Gangsterism and Goofy Visions of New York* 1935
The Menil Collection, Houston

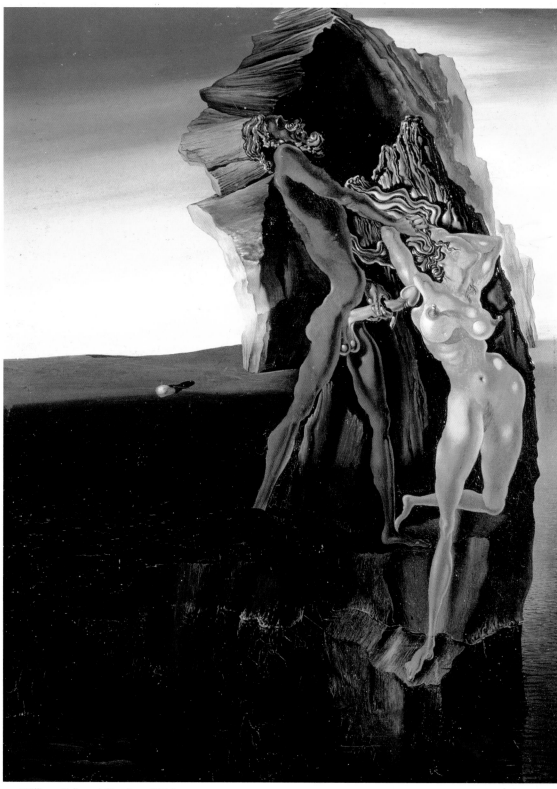

10 *William Tell and Gradiva* 1930
Fundació Gala-Salvador Dalí, Figueres

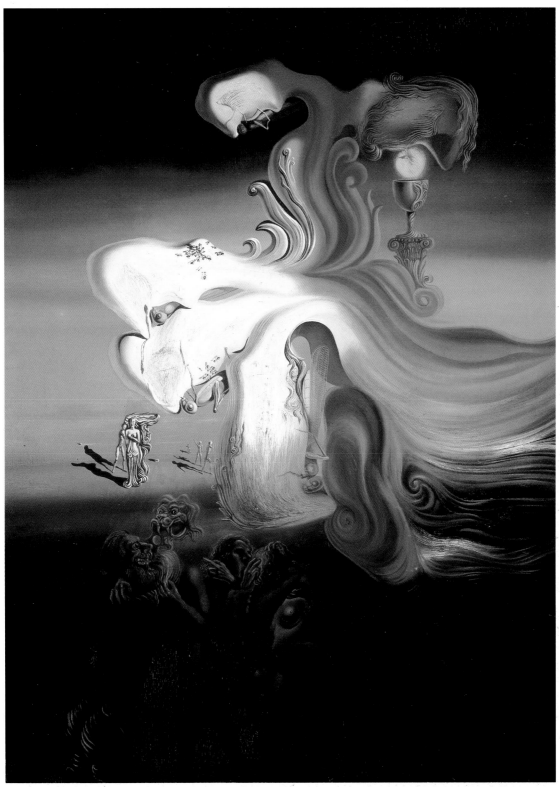

The Profanation of the Host 1929
Salvador Dalí Museum, Inc., St Petersburg, Florida

Gala Dalí: The Eternal Feminine

Fiona Bradley

> Gala, Eluard's wife. It was she! Galuchka Rediviva! I had just recognised her by her bare back. Her body still had the complexion of a child's. Her shoulder blades and the sub-renal muscles had that somewhat sudden athletic tension of an adolescent's. But the small of her back, on the other hand, was extremely feminine and served as an infinitely svelte hyphen between the wilful, energetic and proud leanness of her very delicate buttocks which the exaggerated slenderness of her waist enhanced and rendered greatly more desirable.[1]

Dalí met Gala in the summer of 1929 when she, her husband the poet Paul Eluard, the art dealer Camille Goemans and René Magritte and his wife came to Cadaqués to visit Dalí and to see if André Breton's growing interest in him was justified. Famously Dalí, who was then working hard on the painting *Dismal Sport*, was in an almost hysterical state of excitement and was having problems controlling outbursts of manic laughter caused by his own hallucinations. Gala did not leave Cadaqués with her husband. She stayed with Dalí, curing him of his hysteria and becoming his lover, his business manager, his mediator and, eventually, his wife.

In *The Secret Life of Salvador Dalí* – Dalí's unstable, unreliable and immensely entertaining account of his own life from 'intra-uterine memories' to international super-stardom at the age of 37 – the painter insists that he 'recognised' Gala when he met her for the first time. Much as his *Gala* of 1931 slots a photograph of Gala into the universe of Dalinian pictorial symbols (the grasshopper, the self-portrait mask, the feminine-faced jug or vessel shape which surround her image are all motifs developed in Dalí's work in the years immediately preceding this picture), his writing positions her as part of his ongoing creative and personal concerns. Gala is recognised as the reincarnation of Galuchka, herself a retrospectively invented imaginary friend from the 'authentic false memories' of Dalí's childhood. In love with Gala at the time of writing *The Secret Life*, Dalí inserts into his account of his life several spuriously 'remembered' presentiments of their meeting:

> I was going to know love that summer! And my hands explored upon the body of the terribly precise noon of Cadaqués the absence of a feminine face which from afar was already coming towards me. This could be none other than Galuchka, resuscitated by her growth, and with a new woman's body – advancing, for I saw her always advancing.[2]

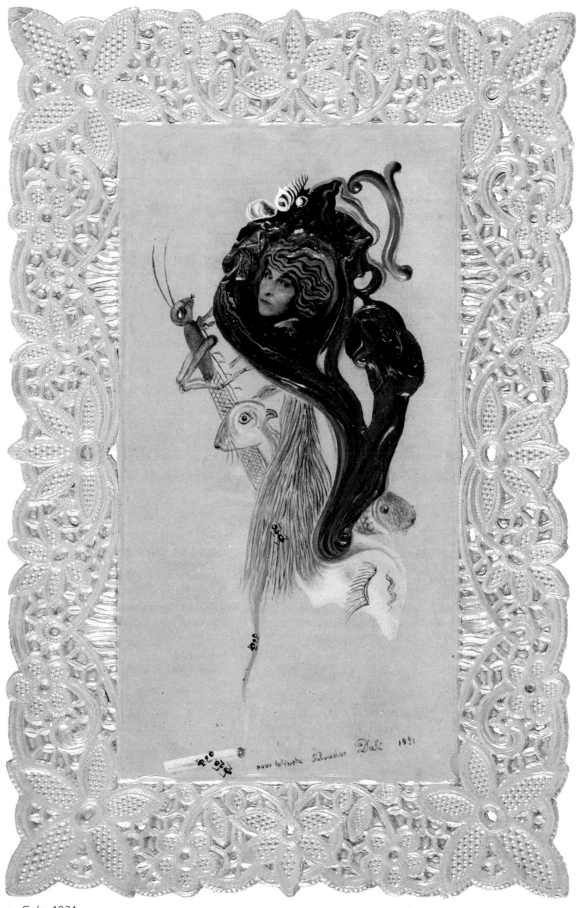

11 *Gala* 1931
Albert Field, New York

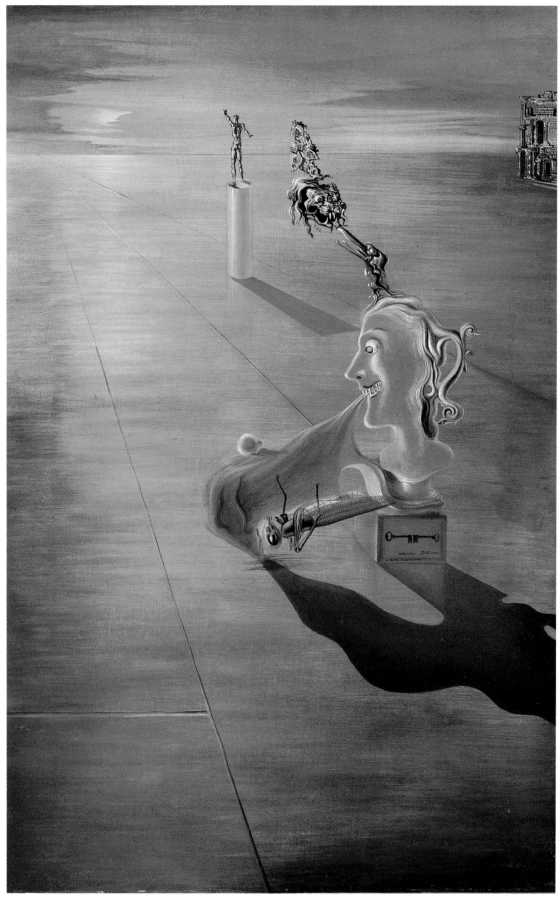

5 *Phantasmagoria* 1929
J. Nicholson, Beverly Hills, California

Gala advances into Dalí's life, and into the careful account of his life which he constructs to support his work (an account which is, in fact, to an extent, his work). He makes Gala into an alter-ego, an absence onto which he can project idealisations born of desire, painting her over and over again in various mythological and pictorial disguises. Recognising her as already part of the constructed and retrospectively reconstructed Dalinian universe, he recodes her image as something already controlled by him: when we see a woman in a painting it is almost always Gala, and when we recognise Gala it is Dalí's Gala at which we look. The joint signatory of his mature paintings, Gala (Salvador) Dalí is someone other than the woman he met and married.

> I call my wife Gala, Galuchka, Gradiva (because she has been my Gradiva), Olive (because of the shape of her face and the colour of her skin), Olivete, the Catalonian diminutive of Olive and its delirious derivatives, Olihuette, Orihuette, Buribette, Burihueteta, Sulihueta, Solibulete, Oliburibuleta, Cihuetta, Lihuetta, I also call her Lionete (Little Lion) because she roars like the MGM lion when she gets angry; Squirrel, Tapir, Little Negus (because she resembles a little forest animal); Bee (because she discovers and brings me all the essences that become converted into the honey of my thought in the busy hive of my brain)…
>
> I also call Gala Noisette Poilue – Hairy Hazelnut – (because of the fine down that covers the hazelnut of her cheeks); and also Fur Bell (because she reads aloud during my long sessions of painting, making a murmur as of a fur bell by virtue of which I learn all the things that but for her I should never know.[3]

Dalí's serial renaming of Gala echoes her christening as Gala in place of her real name, Elena Dmitrievna Diakona, by Paul Eluard when she came from her native Russia to France in 1916 to marry him. Dalí's naming of her, however, is more complex than Eluard's, and is part of the careful strategy of myth-making with which he builds both his and her Dalinian personae. His account of his pet names for his wife tells as much about him as it does about her. Gala is named for her own attributes: Olive, Noisette Poilue and Lionete celebrate aspects of the woman Dalí loves. However, she is also named for her usefulness to and inspiration of her husband: Olihuette, Solibulete and Oliburibuleta allow Dalí to glimpse his own delirious creativity whenever he calls for her, while Tapir, Bee and Fur Bell conjure a willing and rather practical muse.

The muse has one more name: Gradiva. Gala 'has been [Dalí's] Gradiva', surrealist totem and universal muse; 'Gradiva, she who advances'; Gradiva, the woman 'whose gaze pierces walls'. The concept of the muse Gradiva comes originally from a short story written by the

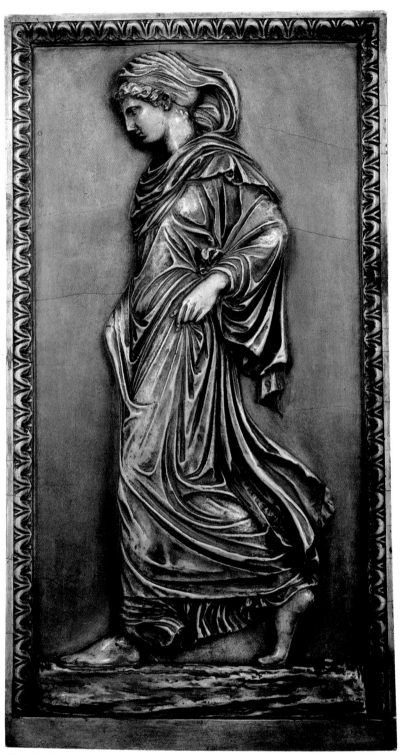

Freud's plaster reproduction of the classical relief 'Gradiva'
Freud Museum, London

German writer Wilhelm Jensen in 1903. In the story, Norbert Hanold, a young archaeologist, becomes obsessed by the figure of a young woman depicted on an antique relief. The woman is walking, and Hanold becomes fixated on her gait, naming her Gradiva, 'the girl splendid in walking', after Mars Gradivus, the god of war striding into battle. Convinced that Gradiva died in the eruption of Vesuvius, Hanold goes to Pompeii, where he catches repeated glimpses of a woman he believes to be her, flitting among the ruins, seemingly disappearing into walls as he chases her. He eventually catches up with her and recognises her – as Gradiva. She informs him, however, that while he does indeed recognise her, it is in fact as Zoë Bertgang, an old childhood friend. She cures him of his paralysing obsession, freeing him to live in productive contentment with her.

In 1907, Jung suggested that Freud, who was at that time interested in working with 'undreamed' (i.e. fictional) dreams, might turn his attentions to this story, and Freud produced *Delusions and Desires in Jensen's Gradiva*, published in 1909. In Freud's analysis, Hanold's obsession with Gradiva is the result of a repressed desire for Zoë Bertgang, the childhood sweetheart. Freud points out that in German Bertgang, like Gradiva, means 'splendid in walking'. Pompeii is the setting for the unearthing of Hanold's repressed fantasies (archaeology becoming a metaphor for the psychoanalytic project) and Zoë/Gradiva a figure who bridges the two worlds of reality and unreality, fact and fantasy, desire and delusion. As she advances from the unconscious mind to the conscious, she connects the hero back to the unrepressed and therefore creative urges freely at play in the reality of the child but all too often ignored in the mind of the adult.

Surrealism was an art form whose practitioners believed firmly in the creative power of the 'merveilleux' or marvellous, a state of limitless creative possibility found in childhood, the irrational and the dream. For surrealist artists, art was a liberating force for the retrieval of this power. Gradiva was an obvious patron saint of the marvellous, and André Breton, the surrealists' leader, borrowed freely from Jensen in the epigram for his *The Communicating Vessels* of 1932, a text in which he makes a plea for the conjunction of the inner and outer worlds: 'and gathering up her skirts in her left hand, Gradiva Rediviva Zoë Bertgang, wrapped in the dreaming gaze of Hanold, with her supple and tranquil gait, in full sunlight on the flagstones, passed to the other side of the street'. The language is that of exchange, of boundaries crossed and barriers eroded; of the marvellous, the place of supreme surrealist possibility where revelation awaits in a fusion of the conscious with the unconscious. Breton repeats the formulation in a pamphlet published to mark the opening of the surrealist Gradiva gallery in 1937: 'on the bridge which links dream and reality, gathering up her skirts in her left hand… GRADIVA'.

8 *Gradiva, Study for 'The Invisible Man'* 1930
Salvador Dalí Museum, Inc., St Petersburg, Florida

Gradiva 1932
Staatliche Graphische Sammlung, Munich

37 *Gradiva* c. 1939
Fundació Gala-Salvador Dalí, Figueres

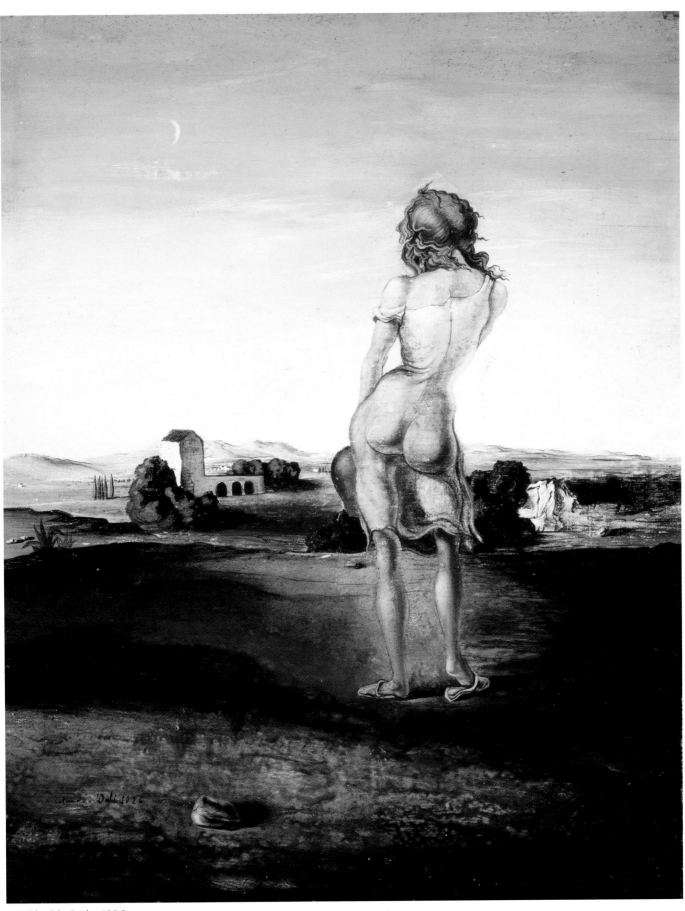

3 *Girl with Curls* 1926
Salvador Dalí Museum, Inc., St Petersburg, Florida

Gradiva, human bridge between illusion and reality, is a surrealist muse. A combination of male fantasy and real-life woman, she is a 'femme-enfant' (child-woman), the surrealist muse incarnate, the vessel through which the surrealist artist communicates with the creativity of his unconscious.[4] Constructed by Surrealism first as 'femme' – the unknowable, ambiguous 'dark continent' of Freudian analysis perhaps – and secondly as 'enfant' with (thanks to the surrealist idealisation of childhood) privileged access to the marvellous, the child-woman was the realisation of a figment of the male imagination. Gala, recognised as the reincarnation of an imaginary childhood friend, rescues Dalí from his inarticulate and hysterical laughter. Already characterised by Eluard as the woman 'whose gaze pierces walls',[5] the woman who can pierce or break down the walls which are metaphorical substitutions for the defences an adult builds over the repressed desires of his unconscious mind, she becomes for Dalí a complete incarnation of the child-woman and muse Gradiva, advancing into his life and work, leading him towards self-discovery.

The earliest figure readable as Gradiva in Dalí's work is *Girl with Curls* dated 1926. Too early to speak of Gala, the girl surveying the plain of Ampurdan, the pictorial stage on which much of Dalí's mature work is set, is nevertheless a convincing representation of the 'absence of a feminine face' which Dalí felt was approaching him; the back view in which he later recognised Gala. Later work, made after Dalí had identified Gala as his Gradiva, concentrates on the archaeological metaphor enacted in her story, and on the doubling of the twin Zoë/Gradiva persona. Gradiva appears doubled in *The Invisible Man* of 1929–33. Occupying the space between invisible figure and architectural background from which he emerges, she helps the viewer distinguish the figure of a man buried – or repressed – within the picture. In *Gradiva Rediscovers the Anthropomorphic Ruins* her role is again that of the revelation of mysteries already known but forgotten (hence *Gradiva Rediscovers...*), the passionate embrace of the two figures in the foreground contrasting with the aridity of the ruins behind them. In *Remorse* or *Sphinx Embedded in the Sand* of the same year, the Gradiva figure has a similar relation to the landscape she surveys, which this time is comprised not of ruins but of rocks, the well known and often painted rocks of the coastline around Dalí's house, the habitual terrain of his pictorial endeavours. Secreted within the figure is the outline of a shoe – a glass slipper perhaps, emphasising the Cinderella-like qualities of the elusive Zoë Bertgang.

Gradiva is the lover-muse through and in whom the lover-artist must rediscover and resolve his creative identity. In the drawing *Gradiva* of 1932, it all seems too late – Gradiva scrutinises a skull, with the rocks behind expressing the sterility of the un-rescued creative imagination. The drawing seems to have something of the Oedipal scenario about it, with Gradiva, as in *Remorse* or *Sphinx Embedded in the Sand* again a Sphinx-like figure, surveying the drastic consequences

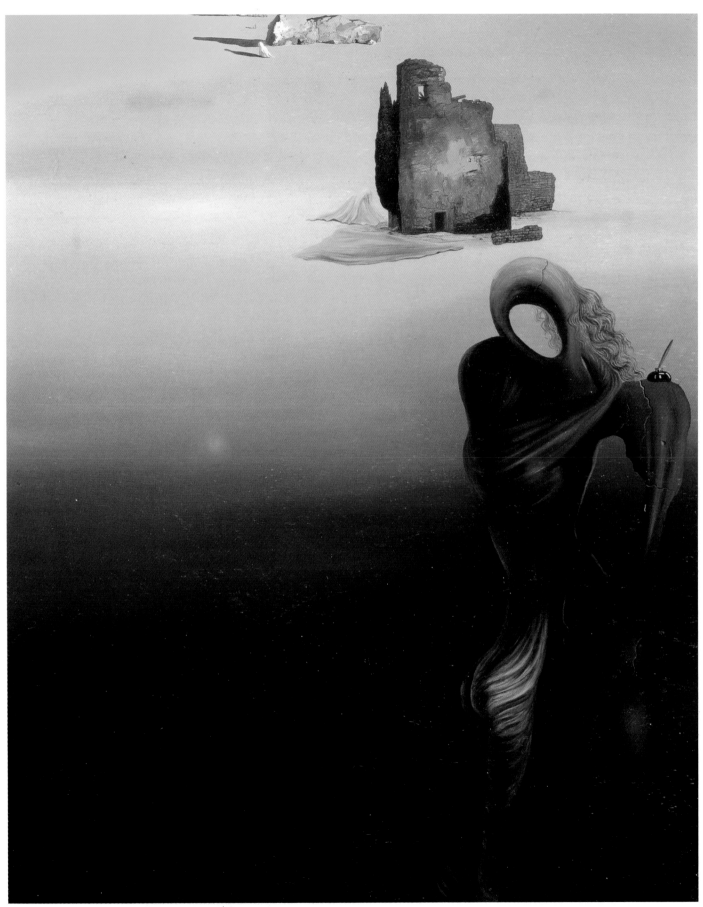

12 *Gradiva Rediscovers the Anthropomorphic Ruins* 1931
Fundación Collección Thyssen-Bornemisza, Madrid

of a challenger's failure while, in the distance, the tiny figures of a father and son await their turn in the battle for supremacy and identity.

An organic form balances precariously on the rocks between Gradiva and her male counterparts; a memory perhaps of the apple belonging to William Tell, another figure through whom Dalí explores the possibilities of the Oedipus story and the beneficiary of Gradiva's powers of sexual liberation in *Untitled (William Tell and Gradiva)*. The stories come together again in the lower section of the drawing *Gangsterism and Goofy Visions of New York*, in which a Gradiva figure looks at herself in a mirror, ignoring the moment of Oedipal competition between William Tell and his son. The son is headless – vanquished in the William Tell/Oedipal scenario, but victorious in the terms of the Gradiva story. He is out of his head, free from the adult repression of his innermost desires, a state seemingly advocated by the rather predatory *Gradiva She Who Advances* of 1939.

Freud's reading of Jensen confers on his Gradiva story the status of myth, elevating it as the expression of a universal truth on a par with the tales of Oedipus and Narcissus. It is possible to draw a parallel between Freud's treatment of Jensen and Dalí's creation of a mythology around Millet's *Angelus:* in *The Tragic Myth of Millet's Angelus*, itself structured like a Freudian case history, Dalí posits the *Angelus* as a similarly 'undreamed' dream, a model for the structuring and restructuring of a male individual in his relationships with a woman. In Dalí's *Angelus* scenario, the man is both father and son, while the woman is mother and sphinx: interrogatory, threatening, but ultimately offering a clue to of the hero's identity.

This maternal sphinx is, inevitably for Dalí, Gala. In *Sugar Sphinx* she sits, with her back to both painter and viewer, surveying the scene of the *Angelus*. In *Gala and the Angelus of Millet Preceding the Imminent Arrival of the Conic Anamorphoses* she looks out from underneath a representation of Millet's picture, and in *Gala's Angelus* the two views of her are united as, still wearing the same jacket, she sits as if looking at her reflection in a mirror which has been removed. Again with her back to the picture plane, she sits on a simple box, her back minutely scrutinised and painted by the artist for whom it is a space of such self-revelatory possibility. Her reflection stares out, subtly altered: the box on which she sits has become a wheelbarrow, and above her head now hangs a Dalinian version of the *Angelus*. Surrounded by the props of Dalí's fascination with Millet's picture, the image of Gala signifies from the context of that fascination; a muse who will lead us forward into knowledge of her pictorial reinventor.

A shifting series of relationships between Dalí and Gala as emblematic man and woman circulate within the painter's work with Millet's *Angelus*. He is husband to her wife, son

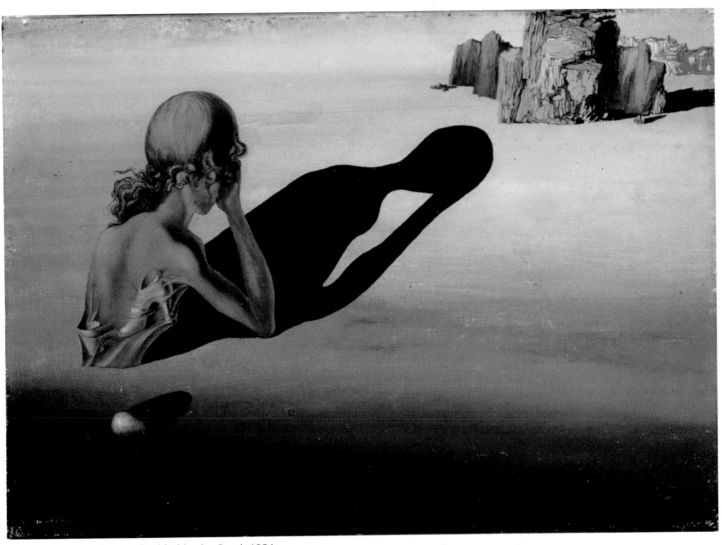

13 *Remorse* or *Sphinx Embedded in the Sand* 1931
Kresge Art Museum Collection, Michigan State University, gift of John F. Wolfram, Michigan

Portrait of Gala (L'Angélus de Gala) 1935
The Museum of Modern Art, New York. Gift of Abby Aldrich Rockefeller

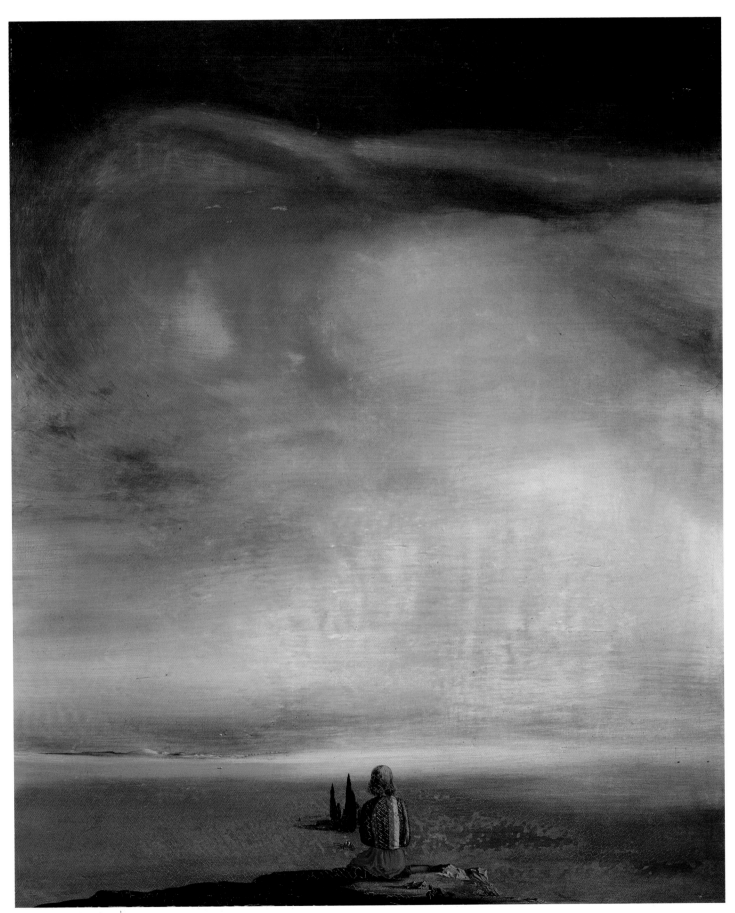

25 *Sugar Sphinx* 1933
Salvador Dalí Museum, Inc., St Petersburg, Florida

to her mother, brother to her sister. The archetypes of the *Angelus* male and female are made by Dalí to chime with the legend of the Dioscuri twins Castor and Pollux, sons of Leda, the mortal impregnated by Zeus in the form of a swan. Two double-yolked eggs were hatched as a result of their union – in one the mortal Castor and immortal Pollux, in the other the immortal Helen and her mortal sister Clytemnestra. Restaging the union of the *Angelus* couple in his relationship with Gala, Dalí proclaims her Leda, mother of the 'univitelline twins', and also, by virtue of her real first name, Helen, sister to him as Pollux, immortalised by Dalí the immortal painter genius.

In *Leda Atomica*, Dalí paints the appearance of the swan Zeus to the naked Gala as Leda. An annunciation scene, the winged carrier of the woman's destiny whispers her future in her ear, a memory perhaps of the legend that the conception of Jesus in the Virgin Mary was achieved by the introduction into her ear of the breath of the Holy Ghost.[6] The Madonna-like qualities of Gala's Leda are confirmed in *The Madonna of Port Lligat* of the same year, in which Dalí relocates Piero della Francesca's Brera Altarpiece to the beach in front of his house at Port Lligat, the same setting as that of *Leda Atomica*, one of whose pregnant eggs has also migrated into this picture.

The Madonna is Gala, her virgin pose copied from a photograph Dalí had previously taken of her as the Virgin Mary. Again as in *Leda Atomica*, the separate iconographic elements of the painting hover in a kind of suspended animation, referring both to the poise and equilibrium of Piero's exemplar of Renaissance perfection, and to Dalí's own excitement in the metaphoric possibilities in the discoveries of atomic physics: that matter is divisible into particles suspended in dynamic tension, capable of imminent revolutionary metamorphosis. The potential of this discovery when applied to stories from the New Testament – God becoming matter in the form of Jesus Christ, the Virgin ascending to heaven 'through the power of her own anti-protons', paradigmatic of 'the paroxysm of the will-to-power of the eternal feminine'[7] – underlies much of Dalí's later work. Here, however, the suspended forms contribute an other-worldliness, a sense of the conjunction of myth and reality which collects in the figure of the mythologised, Dalinian Gala, her head beginning to split in an image of the gaps only she, as muse, may begin to bridge.

Mary, like Leda a mortal woman visited by a metamorphosised god in order that she might bear his child, acts thereafter as a conduit through which her son's mortal counterparts may regain access to the god that gave them birth. A figure of intercession, an agent of mediation between rational man and a state beyond the rational, she is both child-woman (before the Annunciation, she 'knows not a man') and woman-with-child: the Virgin Mother of Catholic divinity.

Mary becomes the Virgin Mother through the action of a male (re)creator. In a sense, she is God's muse, and is close to those incarnations of the surrealist muse (Gala being the supreme example) who owe their pictorial and literary identity to the activity of their men. The muse is the object of desire, of love, and God is, famously, love itself. His transformation of Mary is the result of love: 'God so loved the world that he gave [her] his only son'. God uses Mary as a channel through which to create. That which he creates through her mediation is, as so often with Dalí and Gala, the image of himself.

Gala's wedding ring is clearly visible in *Leda Atomica*, a picture of a mystic marriage which results in the twin immortalisation of herself and Dalí. In the hope of obtaining permission to marry the already-divorced Gala in a Catholic ceremony, Dalí took *The Madonna of Port Lligat* to an audience with the Pope. The visit echoes the one he made Freud, to whom he took his *Metamorphosis of Narcissus*, a picture similarly concerned with doubling and splitting, twinning and separation. In this earlier picture, the figure of Narcissus is doubled – twinned – with an image of a hand holding an egg. The poem Dalí wrote to accompany the picture ends:

> When that head slits
> when that head splits
> when that head bursts,
> it will be the flower,
> the new Narcissus,
> Gala –
> my narcissus.

The splitting head this time, like the two Dioscuri eggs, reveals a pair of twins: Dalí and Gala, Dalí and his Narcissus. In some accounts of the myth of Narcissus, the beautiful youth fell in love with his sister rather than himself, only becoming captivated by his own reflection because he thinks that he sees in his reflected image his sister, who resembled him in every respect. His substitution of himself for his sister both remembers the legend of the Dioscuri (when Castor dies, Pollux, inconsolable at the thought of immortality without him, begs Zeus to let him share it, each twin spending alternate days in the Underworld) and links to Dalí's determined identification of Gala with himself.

For if Dalí and Gala are the 'univitelline twins' Pollux and Helen, they are also, elsewhere in Dalí's writing, Pollux and Castor, the twins who become substitutions one for the other. Dalí's repetitions of Gala, his gradual absorption of her into the proliferating iconography of his recuperated unconscious creativity (recuperated, of course, through her agency as the muse

48 *Study for the Head of 'The Madonna of Port Lligat'* 1950
Salvador Dalí Museum, Inc., St Petersburg, Florida

49 *Gala Madonna* 1953
Perrot-Moore Art Centre, Cadaqués

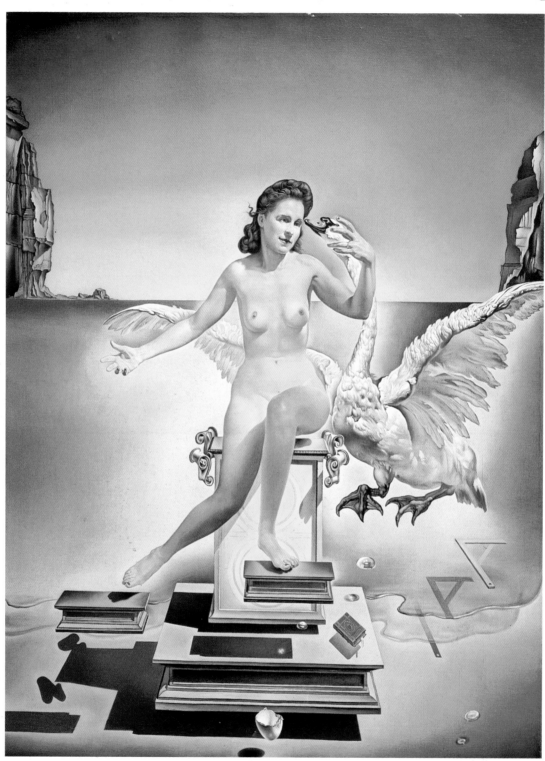

Leda Atomica 1949
Fundació Gala-Salvador Dalí, Figueres

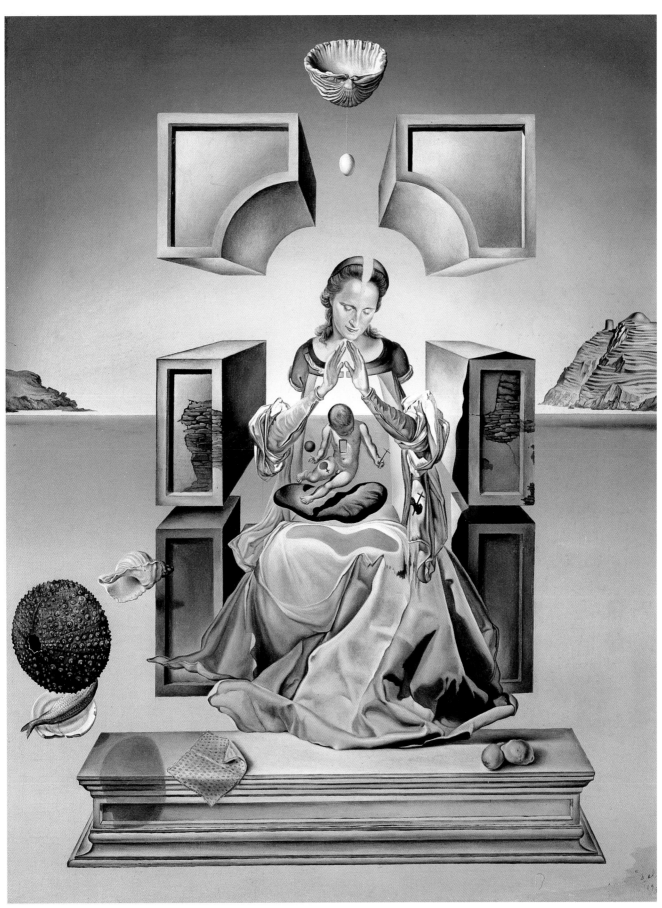

46 *The Madonna of Port Lligat (first version)* 1949
Patrick and Beatrice Haggerty Museum of Art, Marquette University, Milwaukee, Wisconsin, U. S. A.
Gift of Mr. and Mrs. Ira Haupt (59.9)

74

43 *Study for 'Leda Atomica'* 1947
Fundació Gala-Salvador Dalí, Figueres

44 *Study for 'Leda Atomica'* 1947
Fundació Gala-Salvador Dalí, Figueres

Gradiva), in some way claim her as part of that iconography. An extremely privileged part: from her early superimposition onto the motif of the jug-woman in the portrait *Gala* of 1931, the motif paired throughout Dalí's work from 1929 onwards with the self-portrait mask and the grasshopper which is a powerful representation of the painter himself, the image of Gala indicates in some way the presence of Dalí. His portraits of her, though representational, do not subscribe to the mechanisms of realist presentation whereby likeness is guaranteed by the replication of the real-life referent (the sitter) by the painted signifier (the image). Gala as Dalí paints her bears no relationship to Gala as she is or was; although she was a real woman who participated in the practicalities of Dalí's life, she colluded in his reification of her as his Gala, the Gala he recognised as a missing link in the chain of his constructed personality. Dalí often painted Gala from behind, capturing not her actual back view but the back of his 'remembered' Galuchka. He painted her as if in a mirror but, crucially, removed the mirror, confronting his painted Gala not with a 'real' or reflected Gala, but with the appropriated Gala of the Dalinian imagination.

'Good evening Gala, I am going to touch wood so that nothing happens to you. You are me, you are the pupils of my eyes and of your eyes'. When Dalí looks at Gala he sees himself reflected in her. As must we for, as viewers of his work, we see only the Gala constructed by him. Like the Virgin Mary with God the Father, she is defined by the love expressed in his gaze, but also, in some way, defines it. She – child-woman, Gala, Galuchka, Gradiva, Leda and Madonna – is the Eternal Feminine, both the muse-woman whose gaze pierces the walls separating Dalí from his inner creativity, and the vehicle for the elaboration of that creativity. When Dalí paints Gala, he is on home ground.

Notes

1
Salvador Dali, *The Secret Life of Salvador Dalí*, New York 1942, p.229.

2
ibid., p.218.

3
ibid., note to p.248.

4
For a detailed discussion of the 'femme-enfant', see Whitney Chadwick, *Women Artists and the Surrealist Movement*, London 1985.

5
Paul Eluard, *Au Défaut du Silence*, 1925.

6
For a discussion of this legend see Ernest Jones, 'The Madonna's Conception through the Ear: A Contribution to the Relation Between Aesthetics and Religion', London 1914, reprinted Ernest Jones, *Essays in Applied Psychoanalysis*, London 1951.

7
Salvador Dalí, *The Diary of a Genius*, Paris 1964, trans. London [1966], 1990, p.40.

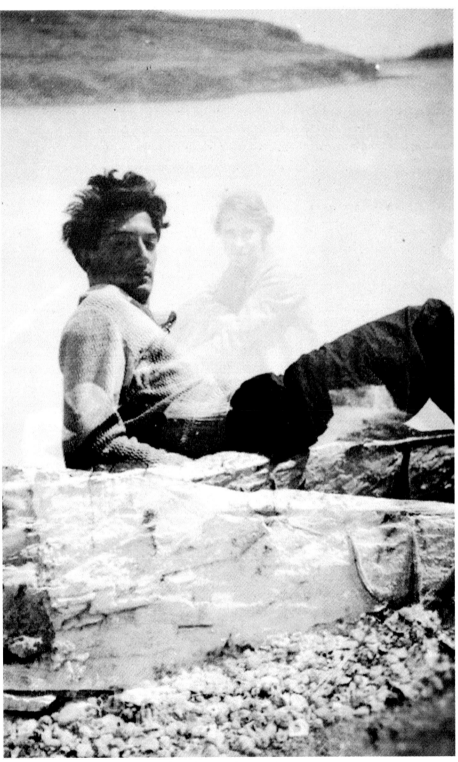

Self portrait of Salvador Dalí with Gala superimposed
Fundació Gala-Salvador Dalí, Figueres

The Metamorphosis of Narcissus: Dalí's Self-Analysis[1]

David Lomas

> It would in fact be very interesting to investigate analytically how a picture
> like this came to be painted.
>
> Freud to Stefan Zweig, 20 July 1938[2]

When Dalí's wish to meet the founder of psychoanalysis was at last realised in 1938, the picture he chose to take with him on his pilgrimage was the *Metamorphosis of Narcissus*. Freud had been forced into exile by the Nazi occupation of Vienna and was living in Hampstead in North London. He was little more than a year away from death and the drawings executed by Dalí following the visit starkly reveal his emaciation. Despite his illness, Freud seems to have been humoured by his visitors that day and is thankful to Stefan Zweig for introducing 'that young Spaniard with his candid fanatical eyes.' On the matter of his painting, Freud's letter expresses admiration for Dalí's technical mastery, although in other respects it seems they were destined not to see eye-to-eye. The surrealists, whom Freud notes bemusedly had adopted him as their 'patron saint', avidly read psychoanalysis and were thoroughly acquainted with its theorems. Tackling a theme central to the psychoanalytic account of subjectivity, one assumes Dalí took the *Metamorphosis of Narcissus* with him in the hope of impressing the master whom he revered.[3] But therein lay a major point of contention. Freud looked upon art and literature, as indeed he looked to myth, to furnish innocent testimony to the truths about human nature unlocked by psychoanalysis. The value of Wilhelm Jensen's novel *Gradiva*, the subject of an extended analysis by Freud, is increased, not lessened, in his eyes when Freud learns that its author was ignorant of his theories, and yet managed to accord precisely with his views about the unconscious mechanisms in dreams, phantasies, and neuroses.[4] Whereas in Dalí's case, quite obviously, any such presumption of innocence would be totally misplaced, since none of the surrealists was better versed in the psychoanalytic corpus than he. The difficulty Freud had with Dalí's Narcissus – in myth a self-deluded figure – is that he is, paradoxically, *too knowing*. With reference to the picture he wrote in his letter to Zweig that: 'From the critical point of view it could still be maintained that the notion of art defies expansion as long as the quantitative proportion of unconscious material and pre-conscious treatment does not remain within definite limits.'

'One of the capital discoveries of my life' was how Dalí rated his first encounter with *The Interpretation of Dreams* back in his art student days in Madrid, adding that he was 'seized

40 *Portrait of Sigmund Freud* 1939
Freud Museum, London

with a real vice of self-interpretation.'⁵ That remark alone would suggest Dalí envisaged a more active role than Freud was willing to grant to the artist, one in which he would be akin to Freud himself when he embarked on the heroic self-analysis that, in the official version of its history, gave birth to psychoanalysis. Imagine for a moment Dalí in the father's place, as he perhaps secretly wished to be, gazing unflinchingly into the depths of his psyche (only the lofty rhetoric jars slightly). Allowing free rein to his vice for self-interpretation, the *Metamorphosis of Narcissus* would be the key document of this self-analysis.

Possibly due to the exigencies of displaying modern art in the museum, it is not widely appreciated that Dalí had intended the *Metamorphosis of Narcissus* to be viewed in conjunction with a poem that he wrote simultaneously and published in the form of an illustrated pamphlet. Only recently has the continuous dialogue in Dalí's work between writing and painting, text and image, which reaches its apogee in the *Metamorphosis of Narcissus*, been recognised.⁶ Viewing the work alongside the poem a surprising picture emerges of this most accomplished Narcissus as he undertakes, in emulation of Freud, his own self-analysis. In particular, the poem alerts us to a thematics of abjection seething beneath its immaculate, airbrushed surface whose presence until now has gone unsuspected. At risk of besmirching a much admired work, I will argue in this essay that the *Metamorphosis of Narcissus* is the culmination of a decade-long preoccupation with the 'phenomenology of repugnance', a term whose relevance to Dalí's practice in the 1930s and significance for how he constructs the figure of Narcissus will be examined. At variance with usual perceptions of Dalí, the accent of the picture is not upon the triumphalism of His Majesty the ego, but rather what Julia Kristeva in connection with the abject has called the 'moment of narcissistic perturbation'.⁷

i. The Prologue

THE FIRST POEM AND THE FIRST PAINTING OBTAINED ENTIRELY THROUGH
THE INTEGRAL APPLICATION OF THE PARANOIAC-CRITICAL METHOD

Preceding the poem is a single page of text adjoining a high quality colour reproduction of the picture, a prologue which serves to establish a framework for viewing and interpreting the visual image.

A quotation from an essay by André Breton from 1934 is strategically recycled which is fulsome in its praise of Dalí's paranoiac-critical method. Appropriately, the passage chosen

draws attention to the sheer versatility of Dalí's creative endeavour and by the simple expedient of omitting the date it appears as if Breton is conferring his blessing on the *Metamorphosis of Narcissus*. Indeed, the intention seems to have been to place the exercise firmly under the aegis of Surrealism, since the poem was published by the *Éditions Surréalistes* and was dedicated to Paul Eluard, one of Surrealism's most esteemed poets. The exact equivalence of poetry and painting that Dalí was aiming to achieve certainly conforms to the surrealist ideal of a *peinture-poésie*. Another factor prompting him to experiment with this hybrid genre may have been his enthusiasm for the Pre-Raphaelites, attested to in an article in 1936 for the surrealist journal *Minotaure*. Dante Gabriel Rossetti's practice of exhibiting paintings and poems of the same title side by side is a notable prece-dent for Dalí's undertaking. It may be that the Narcissus theme is especially amenable to this sort of treatment, since one has available both an established visual iconography and a distinguished poetic lineage from Ovid through to Paul Valéry.[8] The resultant symbiosis of word and image runs counter to modernism's insistence on the autonomy of visual expe-rience, thus reconfirming Dalí's violent opposition to modernism (which he consistently stakes out during the 1930s). For the reader or viewer, an overriding impression created by the combination of image and text is of a duplication of one by the other – the first of many instances of mirroring or doubling that are connected at a fundamental level with the narcissus theme.

Next, the prologue contains a set of instructions about how the tableau should be viewed: a 'mode of observing… the process of metamorphosis of Narcissus represented in the painting opposite.' Dalí had long been in the habit of supplying diagrams setting out the constituent elements of his double and multiple images. The need for these supplements to the painted image must have increased as the visual pyrotechnics became ever more complex, and as his audience expanded to include people unfamiliar with the protocols of viewing art. Dalí recommends that the viewer gaze in a state of 'distracted fixity' whereupon the blurred figure of Narcissus gradually disappears. Is there not a deliberate analogy here between the kind of intent scrutiny Dalí requires of the viewer and that engaged in by the 'hypnotically immobile' Narcissus, absorbed in the contemplation of his reflection? Philostratus, in the *Imagines*, played wittily on the ambiguous doubling and redoubling of illusion (and delusion) permitted by this transaction between viewer and depicted subject:

> As for you Narcissus, it is no painting that has deceived you, nor are you engrossed in a thing of pigments and wax; but you do not realise that the water represents you exactly as you are when you gaze upon it, nor do you see through the artifice of the pool…[9]

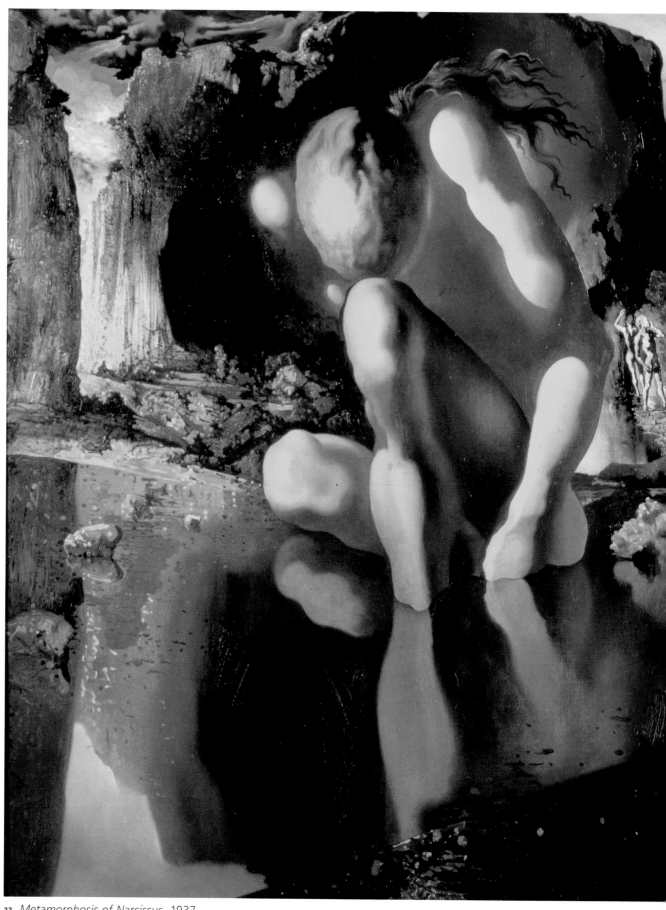

33 *Metamorphosis of Narcissus* 1937
Tate Gallery, London

Painted with all the *trompe l'oeil* resources Dalí could muster, the *Metamorphosis of Narcissus* aims to replicate for the viewer the predicament of Narcissus himself; both are taken in by the power of an illusion. Over and beyond merely illustrating the narcissus myth, then, Dalí's task was, more ambitiously, to interpolate the beholder into a viewing structure that is intrinsically narcissistic.

Finally, the prologue hints at an autobiographical framework for interpreting the poem. It does so by means of a comical exchange between two Port Lligat fishermen, one of whom asks: 'What's up with that boy who looks at himself all day long in a mirror?' The other replies in hushed tones, lest they be overheard, that he has 'an *oignon* in his head' – this we are told is a Catalan idiom corresponding very exactly to the psychoanalytic notion of a complex! There can be little doubt in the reader's mind that the self-infatuated youth referred to is Dalí himself. This literary conceit thus establishes at the outset that Narcissus is primarily a self-referential guise for Dalí, something the end of the poem reasserts, and which is no doubt also pertinent to some of the more recondite intervening details.

ii. The Setting

> On the highest mountain,
> the god of snow,
> his dazzling head bent over the dizzy space of reflections,
> starts melting with desire
> in the vertical cataracts of the thaw
> annihilating himself noisily among the excremental cries of minerals

The poem begins with a description of the landscape which forms a spectacular backdrop to Narcissus in the foreground. Dalí was holidaying at Zürs in the Austrian Alps in April of 1937 when the work was painted, and the surrounding mountains provided his immediate source of inspiration. Edward James, who stayed with him for part of the time, recalls that, it being springtime, the snow was melting and narcissi were everywhere in bloom. Complicating the picture is the fact that, in addition, the setting is strikingly reminiscent of the precipitous landscape seen looking back from the beach near Cap Creus toward the Pyrénées which on their lower slopes are lined with olive groves. Since this stretch of coastline was the scene of some of Dalí's earliest childhood memories, the picture can be understood as referring not only to the present but also to the past. Potentially recapitulated within a single, unified space are all the decisive moments of Dalí's personal history, ranging

from infantile experience through adolescence and adulthood.

The section of the poem given over to evoking the landscape is like an Old Testament prefiguration in which the melting of snow and the germination of narcissus flowers rehearses the eventual disappearance of Narcissus, his melting away and ensuing metamorphosis. In the picture, Dalí employs more direct means to indicate the involvement of the setting in the unfolding drama: at the top right, one can just glimpse the snow god who is like a miniature version, a morphological echo, of Narcissus perched at the water's edge whose inner psychological drama is writ large in the landscape behind him. The stems of the narcissi rise up 'straight, tender, and hard', a virile force of new life, whereas the snow god melts away and is 'annihilated noisily among the excremental cries of minerals'. There is a blatant anthropomorphism behind this contrasting set of images which represent as an event in nature, a cycle of the seasons, the conflict of Eros and the death drive. The outcome of the narrative hinges on which one of these elementary forces of mental life will predominate.

It emerges that Dalí's Narcissus is a suicidal figure under sway of the death drive. One of the more disputed aspects of Freudian theory, the notion of a death drive (*Todestriebe*) was introduced by Freud in the essay *Beyond the Pleasure Principle* (1919) in order to account for the existence of mental phenomena that seemed to contradict the pleasure principle, until then assumed to govern all of unconscious mental life.[11] One of the examples given is the dreams of shellshock victims which each night replay the horrific scenes that caused their illness. As Freud describes it, the death drive is essentially a tendency inherent in organic life to seek the restoration of an earlier, ultimately inanimate state of things; it is 'a kind of organic elasticity… the expression of the inertia inherent in organic life.' Death makes its presence everywhere felt in the *Metamorphosis of Narcissus*, however for the moment let us note as one of the basic manifestations of the death drive what Freud is led to characterise as a demonic compulsion to repeat. Dalí's use of a proleptic device whereby the first section of the poem dealing with the landscape setting anticipates his subsequent description of Narcissus sets in train a process of repetition within the narrative that could be associated with the insistence of the death drive. The deceptively picturesque image of narcissi flowering beneath a spring sky actually presupposes that Narcissus has already died. Narcissus, we can say, is dead in advance of his dying; death resides within him as a kind of latency.' I can scarcely enumerate for you all the things that I (a modern Midas) turn into – excrement.'[12]

That which incites disgust, the disgusting, is another of the guises of the death drive. On first joining the surrealists, Dalí published a manifesto setting out his provocative aesthetic

credo. Titled *L'Ane Pourri* (The Rotten Donkey), it warns 'art critics, artists, &c., that they need expect nothing from the new surrealist images but disappointment, distaste and repulsion.'[13] More consistently than any other artist in the period – and in a way that chimes with the preoccupations of a good many contemporary artists – Dalí's work during the decade of the 1930s explores the terrain of the abject: bodily effluvia, secretions and excreta, putrefaction, and so forth. On more than one occasion he acknowledges as a theoretical support for his speculations in this area an essay on the phenomenology of disgust by a Hungarian author Aurel Kolnai, published in German in 1929.[14] This crucial text has until now been unexamined in literature on Dalí yet a brief outline will suffice to demonstrate its relevance to the *Metamorphosis of Narcissus*.

The list of disgusting things enumerated by Kolnai reads like an inventory of Dalinian obsessions. Chief among them is putrefaction, the most fundamental object of disgust according to Kolnai. He refers to the disgusting character of excrements and states that tactile sensations linked to viscous materials, and simply 'the soft', are liable to incite disgust.[15] Of interest to us is Kolnai's explanation of disgust as one of a series of so-called reactions of defence. Noting that disgust is often accompanied by a macabre seduction, seeming to comprise an integral part of the affect, he asserts that 'the invitation actualises the defence.' On this point, Dalí virtually paraphrases Kolnai, writing: 'One exhibits repugnance and disgust for that which at root one desires to approach and from this arises an irresistible "morbid" attraction, translated often by incomprehensible curiosity for that which appears as repugnant.'[16] Kolnai proceeds to argue in a key section of his essay on *The Relation of Disgust to Life and Death* that our psychic ambivalence regarding death lies at the basis of most reactions of disgust (presumably this is why he considers putrefaction as a fundamental cause). Once again, Dalí accurately conveys the bones of Kolnai's argument when he suggests that 'repugnance [is] a symbolic defence against the vertigo of the death drive (*les vertiges du désir de mort*)'.

'Everything disgusting "sticks" in some manner to the subject, surrounding it by its proximity, by its emanation' writes Kolnai. A rocky outcrop behind Narcissus surrounds and, so to speak, adheres to him. Narcissus is assailed by 'excremental cries of minerals', thereby connecting this backdrop with the scatological landscape depicted in *Accomodations of Desire* (1929). Disaggregation of living matter is what primarily accounts for the feelings of disgust aroused by faeces, claims Kolnai. At certain points, notably where the chocolatey brown earth abuts against the knuckles of the terrifying fossil hand, the painterly illusion verges on decomposing into its constituent pigment and we are compelled to think of paint as a material equivalent of excrement. More repellent still is the shadowed area across the foreground, its sickly greenish-grey the unmistakable hue of decaying flesh. One of the

more novel aspects of Kolnai's account is his evocation of a sort of 'vital exuberance', a paradoxical intensification of life in the midst of decay. He speaks of an *éclat* and tumultuous excess in decomposition where even colours seem more vivid than normal. Dalí, for his part, recalls seeing a decaying donkey swarming with ants and blow flies which he mistook for sparkling gemstones, and it is tempting to connect the lightning flash atmosphere and intense, saturated colour of the *Metamorphosis of Narcissus* with this short-circuiting of life. Similarly, the textual evocation of the setting contains a surfeit of adjectives – 'swarming', 'inconsolable silence', 'the deafening armies of germinating narcissi' – inducing in the reader a feeling of over-ingestion that borders on the nauseous.

The relationship living beings have to the space that envelops them was the theme of a fascinating article by Roger Caillois which appeared in *Minotaure* in 1935.[17] Caillois takes as a paradigm for this relation the phenomenon of mimicry in which organisms come to resemble closely aspects of their non-living surrounds. Rejecting the usual explanation of mimicry as a form of camouflage that protects animals from their predators, for Caillois, space itself assumes the properties of a predator, encroaching on living beings he imagines as ensnared within it and devouring them. Mimicry, he says, erases distinctions between the living and the inorganic. It does not enhance life, but invariably diminishes it. Drawing overtly upon the Freudian notion of the death drive, Caillois writes that assimilation by space 'is necessarily accompanied by a decline in the feeling of personality and life... *Life takes a step backward*.' It emerges that Caillois' primary concern is with human subjectivity and its 'capture' ('*captation*') by space for which mimicry provides a convenient metaphor. Moving from the realm of biology, Caillois claims to discern a similar impulse at work in Dalí's imagery which he maintains is 'less the expression of ambiguities or of paranoiac "plurivocities" than of mimetic assimilations of the animate to the inanimate.' It seems possible that such ideas had some bearing on Dalí's later representation of Narcissus whose blurred contour is proof that he is already well on the road to merging with the inanimate. Prey to what Caillois defines as 'a real *temptation by space*', Narcissus is according to Dalí 'absorbed by his reflection with the digestive slowness of carnivorous plants'. A scrawny greyhound at the right-hand side of the picture scavenging on an animal carcass is a visual counterpart to such images of devouring space with which the poem is replete. Evidently a late addition to the picture, the dog is unmentioned in the poem, however Dalí's letter to James remarks that it looks 'very good in front of this ferocious countryside under an orb which seems to reclaim vegetation.'

iii. The heterosexual group

> Already, the heterosexual group, in the famous poses of preliminary expectation, ponder conscientiously the imminent libidinal cataclysm, carnivorous flowering of their latent morphological atavisms.

The poem proceeds from a description of the landscape to what is termed the 'heterosexual group' in the middle distance. Clearly, these figures are meant primarily as a foil to Narcissus whose isolation from them is stressed, though beyond that their significance is obscure. In the poem, Dalí has taken the trouble to specify each individual as a distinct ethnic or national type – they comprise a veritable 'League of Nations', and given the ominous situation in Europe in April 1937, it may be that they are supposed to allegorise these background political events.

More plausible, in my view, is the suggestion that they depict the assorted suitors, male and female, whose amorous designs Narcissus obstinately resisted. Ovid avers that 'many men, many girls desired him; but (there was in his delicate beauty so stiff a pride) no men, no girls affected him.'[18] Most famous of these unlucky admirers was the nymph Echo who pined away in despair until her voice was all that remained of her. An earlier version of the myth tells of a young man called Ameinias who was smitten with love for Narcissus but he too is spurned and so kills himself. Nowadays, Narcissus would probably be diagnosed as suffering from a phobic anxiety about physical contact with others. Julia Kristeva evokes his solipsistic withdrawal in terms that have special resonance for Dalí, remarking that Narcissus is 'indifferent to love, withdrawn in the pleasure that a provisionally reassuring diving-suit gives him.'[19] As an adolescent, Dalí reports in *The Secret Life*, that he craved only the 'imperialist sentiment of utter solitude' and the chapters of his confessional autobiography that precede his fateful meeting with Gala are littered with frustrated admirers whose torments alone are a source of vicarious pleasure for him. A painted version of Narcissus attributed to Tintoretto has a group of figures in the middle ground who Stephen Bann argues are the exasperated *amores* in pursuit of their elusive quarry, and such an interpretation best accounts for the element of sexual threat emanating from the similarly placed group in Dalí's picture.[20] They strut about aggressively flaunting their sexual attributes like lethal weapons; using a phrase Dalí first coined to describe the female praying mantis about to devour its mate during the act of copulation, they adopt the 'famous poses of preliminary expectation'. The prominence given to the heterosexual group by the poem is hence inversely proportional to their diminutive scale in the painting where a bright red cloth girding the loins of a male near the centre of the group is the only giveaway to the intense psychical accent placed upon them.

Whether or not these figures are identifiable people from Dalí's past we can only surmise. What is indisputable however is that they are a club from which he is firmly excluded. That Dalí is implicated in a narcissistic and by inference *homo*sexual relation in the foreground is a hypothesis to which we shall return.

iv. Narcissus and his Double

> Narcissus annihilates himself in the cosmic vertigo
> in the deepest depths of which
> sings
> the cold and dionysiac siren of his own image.
> The body of Narcissus flows out and is lost
> in the abyss of his reflection

Finally, after the dress rehearsal, comes Narcissus. This section of the poem discusses in turn the component elements of the double image. Consistently misunderstood by commentators on the picture, the purpose of these 'simulacra' is essentially to dramatise the ambivalent attitude which attaches to psychic representatives of the death drive. Kolnai's axiom that 'the invitation activates the defense' succinctly expresses the relationship between the parts.

On the left is Narcissus who presents us with 'the image of desire behind simulacres of terror.' Poised precariously above the abyss of his own reflection, Narcissus is half in love with an easeful death, only too ready to answer its hypnotic siren call. In the poem 'L'Amour' from *La Femme Visible*, a text that adumbrates many of the motifs in the *Metamorphosis of Narcissus*, Dalí insisted that self-annihilation is one of our most violent and tumultuous unconscious desires. A succession of poetic images narrate Narcissus's dissolution as a bounded, unified self until he attains at the end a pleasantly narcotic state of oblivion: 'incurable sleep, vegetal, atavistic, slow'.

The irresistible pull of the death drive manifests as an inexorable diminution of life force – 'Narcissus, you're so immobile one would think you were asleep', Dalí remonstrates with an unresponsive *alter ego* – and as a far-reaching regression that sees narcissism equated with the world of infantile autoeroticism. Dalí assuredly had read in Lecture 26 ('The Libido Theory and Narcissism') of the *Introductory Lectures on Psychoanalysis* that:

> Sleep is a state in which all object-cathexes, libidinal as well as egoistic, are given up and withdrawn into the ego… The picture of the blissful isolation of intra-uterine life which a sleeper conjures up once more before us every night is in this way completed on its psychical side as well. In a sleeper the primal state of distribution of the libido is restored – total narcissism, in which libido and ego-interest, still united and indistinguishable, dwell in the self-sufficing ego.[21]

Narcissus yearns to recreate the blissful solitude of life *in utero*. Crouching down in what can best be described as a foetal position he is bathed in a warm ethereal glow. When Dalí came to write a chapter of *The Secret Life* about his preternaturally distinct memories of life in the womb it is something very similar to this that he purports to remember: 'The intra-uterine paradise was the colour of hell, that is to say, red, orange, yellow and bluish, the colour of flames, of fire; above all, it was soft, immobile, warm, symmetrical, double, gluey.'[22] In *The Birth of Liquid Desires* of 1932, the putative son, another Narcissus, immerses his hand in a fountain contained inside a cavernous, overtly uterine, space. That this motif, with its connotations of a wished for return to pre-natal existence, carries over to the *Metamorphosis of Narcissus* is shown by one of the studies for it. Following a line of argument from *L'Ane Pourri* it is evident that Dalí seeks to represent in this manner 'the dream of a "Golden Age" concealed behind the ignominious scatological simulacre.' Compounding this set of associations, in the final picture the space that cocoons Narcissus basically recapitulates the shape of his head which the poem describes as like a chrysalis; consequently, it is a tomb in which he dies and becomes invisible, but also a place where he is preserved in order later to be reborn.

If the figure of Narcissus encapsulates the seductive enticements of the death drive, the converse is true of the colossal stony hand on the right of the picture. Such exquisite details as a crack running the length of the thumb nail, over which Dalí has laboured with seemingly perverse delight, cause us to recoil in abject horror before a simulacrum of terror.

> His head supported by the tips of the water's fingers,
> at the tips of the fingers
> of the insensate hand,
> of the terrible hand,
> of the coprophagic hand,
> of the mortal hand
> of his own reflection.

The Birth of Liquid Desires 1931–2
Collezione Peggy Guggenheim

32 *Study for 'Metamorphosis of Narcissus'* 1937
Courtesy Helly Nahmad Gallery, London

Ovid extracts remarkable poignancy from the reciprocal exchange of glances and gestures as Narcissus moves in unison with a partner who mimes his every move: 'when I stretch my arms to you, you stretch yours back in return'.[23] While deriving its rationale from this gesture, Dalí's poem is devoid of the gentle lyricism that suffuses Ovid's verse. The hand that reaches out toward me, my hand, has become a dreadful, alien thing.

The Secret Life recounts an incident that must have occurred only a matter of months before these lines were written while Dalí stayed at Cortina d'Ampezzo in the Dolomites on his first trip to Italy. Over several days he had noticed with growing fascination a dried glob of mucus adhering to the lavatory wall. When curiosity finally got the better of him and he tried to peel it off, it became lodged under a fingernail of his right hand. An infection set in soon afterwards causing the hand to become swollen. As Dalí lay alone on his hotel bed (Gala had departed temporarily for Paris), the diseased part appeared to detach from the rest of his body, confronting him in the shape of an offensive, over-sized *memento mori*: 'I imagined my hand already separated from my arm, a prey to the livid first symptoms of decomposition.'[24] Like the head of death that Kolnai says grimaces at us from the place of the abject, this cadaveric hand was a chilling reminder of the death (drive) that infects life.

The double image of a hand holding an egg from which springs a narcissus flower is without doubt one of the most startlingly original products of Dalí's feverish imagination. While the general configuration is somewhat reminiscent of the hand in Max Ernst's *Oedipus Rex* the emotional tenor plainly is not. A severed hand swarms with ants in a scene from *Un Chien andalou* but in the *Metamorphosis of Narcissus* the hand is ossified, resulting in a disconcerting merging of organic and inorganic properties. Inspiration for 'the limestone hand, the fossil hand' may have come partly from Ovid who employs a metaphorics of the petrified and statuesque to describe Narcissus, spellbound by his reflection, as 'like a statue carved from Parian marble.'[25] Dalí's main purpose in transforming living flesh into a limestone cast was to make palpable the work of the death drive. As it does elsewhere in his work, notably in *The Lugubrious Game*, the enlarged hand could refer as well to the act of masturbation. Such a reading is supported by the onanistic repetition in this section of the poem as it rises toward its dreadful crescendo; in this context, the line 'The seed of your head has just fallen into the water' is readily interpreted as describing an ejaculation. Masturbation is linked with deathliness possibly through its forbidden, sinful aspect and its connotation of a sterile pleasure disengaged from the object in the external world and redirected toward the subject's own body.

The hand which incites only disgust and terror corresponds to a part of the self that has been rejected, literally abjected, only to return in magnified form as a frightening hallucination.

Still from *Un Chien andalou* 1929

There is the possibility of a link between the allusion to homosexuality noted earlier in the poem and the mechanism of paranoiac projection involved in creation of this persecutory double. It stems from the same anxious need to disavow that impels Dalí to declare with unexpected vehemence: 'I am not a homosexual'.[26] The homoerotic content of the Narcissus myth itself is inescapable (and might, incidentally, account for its scarcity in surrealist art and literature). As he lay beside the water's edge, 'admiring all the features for which he was himself admired', Narcissus initially failed to realise that the youth whose beauty aroused his ardent desire was in fact himself. Two of the most famous treatments of the Narcissus subject by Cellini and Caravaggio revel in the element of scopophilic pleasure in the Ovidian source. Had Dalí availed himself of the chance to see their works at firsthand on his trip to Italy, he surely would have noticed in Caravaggio's *Narcissus* a double image worthy of himself: that curiously inept depiction of the right knee which Stephen Bann regards as a phallus, but is perhaps more like a buttock. In his picture Dalí goes one better, twinning the flexed knee with its reflection so that both buttocks are visible together. One can regard it as symptomatic that the poem conceals the true nature of this fantasy by displacing it onto a male figure in the heterosexual group, a blond German with 'brown mists of mathematics in the dimples of his cloudy knees.'[27] In its psychoanalytic usage, Dalí was cognisant of an association between the topoi of narcissism and homosexuality from Freud's Leonardo case study. Those interpreters of the *Metamorphosis of Narcissus* who have broached this issue have tended to point the finger of suspicion at Dalí's intense friendship with the poet Federico García Lorça which reached a high point when they holidayed together at Cadaqués in the summer of 1927.[28] Without wishing to discount this suggestion, a more promising candidate for our suicidal Narcissus in the grip of the death drive is the writer René Crevel who stayed with Dalí and Gala at Port Lligat on a number of occasions in the early 1930s and was his most loyal supporter in the surrealist camp. Crevel's tragic death in 1935, like that of the homosexual protagonist of his novel *La Mort Difficile* (Difficult Death), is said to have deeply distressed Dalí, although he later tried to make light of it.

There are reasons for thinking that Dalí was looking at the work of de Chirico with renewed interest in 1937. A symmetrical composition not dissimilar to that which he employs can be seen in a *Self-Portrait* of 1922 by de Chirico, one of several images painted in the early 1920s which incorporate an uncanny, Medusa-like '*pietrificazione*' of the subject. While the Narcissus myth is not explicitly invoked by de Chirico, nevertheless it is implied in the way his relation to the mirror image is conspicuously foregrounded in the series. Another of these self-portraits has the artist reaching toward the front plane of the picture as though he were trying to touch his reflection, like Narcissus, in the course of painting it. Whilst it is difficult to establish with any certainty that Dalí knew examples of these works, all of

33 *Metamorphosis of Narcissus* 1937, detail
Tate Gallery, London

Michelangelo Merisi da Caravaggio
Narcissus c. 1600
Galleria Nazionale d'Arte Antica, Rome

which date from after de Chirico's return to Italy, he undoubtedly would have been familiar with the earlier *Portrait of Apollinaire* where a marble bust in the foreground acts as a double to a profile portrait of the poet behind. Apart from the example of his painting, de Chirico's parallel literary output afforded another valuable model for Dalí. This side of his creativity was greeted with enthusiasm by the surrealists who published several of these texts, generally in a poetic vein, conjuring the sorts of enigmatic scenarios depicted in his painting. Despite a very public, acrimonious row with Breton over issues of classicism and tradition, his attempt at a novel, *Hebdomeros*, was also unreservedly praised by the surrealists. In the manner of a *roman à clef*, an obscure personal mythology serves as a neutral vehicle for autobiography – a tactic, also evident in de Chirico's adoption of the myth of the dioscuri to represent himself and his brother Alberto Savinio, that we may consider germane to Dalí's self-mythologising via the figure of Narcissus. That Dalí had already by 1937 made the decision to become classical, as he put it, and evinced a growing interest in the Italian Renaissance may have disposed him to respond sympathetically to the strains of classical myth in de Chirico. By contrast, it would seem that Breton had in mind the proto-surrealist works typical of de Chirico's metaphysical period when he spoke presciently in 1922 of 'a new mythology in formation'.

vi. The Metamorphosis

> When this head splits
> When this head cracks
> When this head shatters
> it will be the flower,
> the new Narcissus,
> Gala –
> my narcissus.

Just as the poem reaches its terrible finale, the death foretold by the Ovidian myth and that we now expectantly await, is miraculously averted. In what appears as almost a sleight of hand, Eros – life, immortality – snatches Dalí back from the grip of the death drive. Edward James, who was responsible for a translation of the poem and evidently found this ending rather unsatisfactory, observed: 'Dalí ends by turning the poem with his last lines into a tribute to his wife; but, graceful though this is, it seems to me out of place in the context and dragged in *"par quatre épingles"'*.

The greyhound

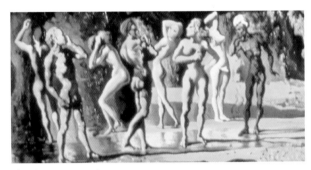

The heterosexual group

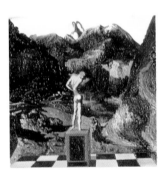

The god of snow

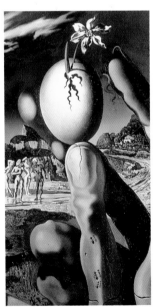

The stony hand

Details from *Metamorphosis of Narcissus*, 1937
Tate Gallery, London

So love wins out in the end. Dalí recounts a similar tale in *The Secret Life*, portraying Gala as the intercessor whose love enables him to conquer the alarming miscellany of neurotic tics and obsessions that were a source of consternation to all around him. They met when she and Paul Eluard, along with the dealer Camille Goemans, René Magritte and his wife, descended on Cadaqués to holiday with Dalí in August of 1929. It is only appropriate that the flames of their love were kindled in the very setting of the *Metamorphosis of Narcissus*. In terms of the poetic narrative this event functions to domesticate Dalí's wayward desire, rechanneling it in the direction of a normative heterosexuality. Narcissism is thus safely reinscribed as a transitional phase in a developmental schema that reaches its socially acceptable terminus in mature object love. After the concerns voiced by the fishermen of Port Lligat about the self-infatuated youth in their midst, one is prepared to believe that this denouement happily coincides with Dalí's cure.

It may not be coincidental that Breton opened the Galerie Gradiva in 1937, named in homage to a novel by Wilhelm Jensen which might never have come to the attention of the surrealists had it not been a subject of Freud's celebrated study.[29] It is the story of a young archaeologist, Norbert Hanold, who falls into a delusional fantasy about a girl represented on a Roman relief whom he names Gradiva. He believes she is real and after dreaming that she was buried in the eruption of Vesuvius sets off to Pompeii in search of her. It transpires that the source of his delusion is the repressed memory of a childhood sweetheart, Zoë Bertgang, whom he encounters as if by chance whilst wandering the streets of Pompei. Realising the nature of his disturbance, Zoë initially acquiesces in the delusion by pretending to be Gradiva: transferring his love back onto herself, she effects his cure. Freud marvels at her skill in a role which he compares to that of the analyst, while the surrealists were enchanted by this touching vignette because of the redemptive power of love it revealed. If, indeed, it had been Dalí's intention to place the *Metamorphosis of Narcissus* under a surrealist banner, he could not have done so more unequivocally than by endorsing this article of the surrealist faith.

And yet, the trite conventionality of the ending sows doubts about its sincerity. A closer look reveals that the reform of Narcissus is less complete than had at first appeared: as 'my narcissus' he surreptitiously enlists Gala into the class of narcissistic love objects. From the extreme idealisation of her, it can be inferred that she is an externalised portion of Dalí's ego – an ego ideal in which she is to satisfy his narcissism. We conclude, with Freud, that: 'What he projects before him as his ideal is the substitute for the lost narcissism of his childhood in which he was his own ideal.'[30] Of relevance to this state of affairs, a variation of the narcissus myth is recorded in which Narcissus, enamoured of his reflection in the water, mistakenly imagines it is the face of a beloved twin sister who had died. Dalí is a

more knowing Narcissus who comprehends that it is really himself whom he loves in the guise of an other, when he christens Gala 'the new Narcissus'. His infatuation with her, because it is such a perfect embodiment of the Bretonian surrealist ideal of *amour fou*, in fact discloses its true face. Narcissus is nowhere to be seen in Surrealism because narcissism is everywhere projected onto *la femme aimée*. A further point, going back to our observation about Surrealism and homophobia, concerns the status of erotomania as a disavowed homosexual wish. Dalí's uxorious devotion to his wife, supplanting and obliterating his former passionate friendship with Lorça, would seem to derive its intensity in part from a vigorous effort at disavowal. In as far as their relationship is an exemplary instance of surrealist *amour fou*, it permits us to recognise that Breton's notorious homophobia was not incidental, an unexamined prejudice on his part, but instead a necessary counterpart of the surrealist doctrine of love.

'Narcissus knows one cannot go beyond narcissism' writes Julia Kristeva.[31] Exceeding the parameters of an affliction from which Dalí might expect to be cured, maybe the picture and accompanying poem ought to be retitled *The Persistence of Narcissism*. But what of the insistence of the death drive? Does the ending succeed in bringing that to an end? 'Now the great mystery draws near, the great metamorphosis is about to take place' – in terms that are perhaps meant to evoke the mystical doctrine of the transubstantiation (Salvador=Saviour), we are told that the metamorphosis of Narcissus is imminent.[32] The next sentence describes the complete disappearance of his corporeal body, to be resurrected as the flower that springs from his blood and whose annual rebirth ensures his immortality. Dalí's final stanza supplies the reader with an updated, psychologised form of this myth, namely the creation of a narcissistic double of himself in Gala. Freud, quoting Otto Rank, writes that the double: 'was originally an insurance against the destruction of the ego, an "energetic denial of the power of death".'[33] In Ovid's poem as in Dalí's, Narcissus both dies and becomes immortal, ie. does not die. Narcissism is cured yet persists, death is denied yet it too insists. The *Metamorphosis of Narcissus* occupies a uniquely important place in Dalí's oeuvre but the work of self-analysis it embarked upon would prove to be an analysis interminable.

Notes

1
A version of this essay was presented at 'Surrealism Laid Bare', a conference at the Edward James Foundation, West Dean, May 1998. My thanks to Sharon-Michi Kusunoki, archivist at the Edward James Foundation, for making available correspondence concerning the *Metamorphosis of Narcissus* which was purchased by James directly from the artist in 1937.

2
Sigmund Freud, *Letters of Sigmund Freud 1973–1939*, ed. E.L. Freud, London 1961, p.444.

3
For a useful introduction to the complex and contradictory status of narcissism in Freudian theory, see Joseph Sandler et al., *Freud's 'On Narcissism: An Introduction'*, New Haven and London 1991.

4
Sigmund Freud, 'Delusions and Dreams in Jensen's "Gradiva"' (1907), *Penguin Freud Library*, vol.14, p.33–116.

5
Salvador Dalí, *The Secret Life of Salvador Dalí*, tr. Haakon M. Chevalier, London 1948 [1942], p.167.

6
See Haim Finkelstein, *Salvador Dalí's Art and Writing 1927–1942. The Metamorphoses of Narcissus*, Cambridge, New York and Melbourne 1996.

7
Julia Kristeva, *Powers of Horror. An Essay on Abjection*, tr. Leon S. Roudiez, New York 1982, p.14.

8
See, in particular, the lineage traced in Stephen Bann, *The True Vine. On Visual Representation and the Western Tradition*, Cambridge 1989, ch. 4 and 5.

9
Philostratus, *Imagines*, tr. Arthur Fairbanks, London 1981, Book I, no.23, p.91.

10
Dalí writes to Edward James (15 June 1937), inviting him to explore the geological recesses of his newest acquisition, but warning him with a mischievous wit: 'don't tire yourself too much, and don't fall into the water like him.'

11
Sigmund Freud, 'Beyond the Pleasure Principle' (1919), in *Pelican Freud Library*, vol.11 (The essay was available in French translation in 1927).

12
Sigmund Freud, 'Letter 79. Extracts from the Fleiss Papers,' *The Standard Edition of the Complete Psychological Works of Sigmund Freud*, London 1966–74, vol.1, p.273.

13
Salvador Dalí, 'L'Ane Pourri,' in *Le Surréalisme au Service de la Révolution*, July 1930, no.1, p.9–12.

14
Aurel Kolnai, 'Der Ekel [Disgust]', *Jarhbuch fur Philosophie und Phaenomenologische Forschung*, ed. Edmund Husserl, Halle 1929, p.515–569.

15
Kolnai makes a point of commenting that strong-smelling cheese contains something that must be called putrid. One is reminded of the genesis of Dalí's famous 'soft' watches.

16
Salvador Dalí, 'L'Amour', from *La Femme Visible*, Paris 1930.

17
Roger Caillois, 'Mimétisme et Psychasthénie Légendaire,' in *Minotaure*, no.7, 10 June 1935, 5–10. My thanks to Briony Fer for reminding me of this essay.

18
Ovid, *Metamorphoses*, tr. Mary Innes, London 1955, Book III, lines 353–56.

19
Julia Kristeva, *Tales of Love*, tr. Leon S. Roudiez, New York 1987, p.35.

20
Bann, op.cit., p.130.

21
Freud, *PFL*, vol.1, p.466.

22
Dalí, *The Secret Life*, p.27: Dalí's representation of Narcissus also correlates closely with Ovid's description: 'As golden wax melts with gentle heat, as morning frosts are thawed by the warmth of the sun, so he was worn and wasted away with love, and slowly consumed by its hidden fire.' Ovid, op.cit., lines 487–90.

23
Ovid, op.cit., line 458.

24
Dalí, *The Secret Life*, p.367.

25
Ovid, op.cit., line 419.

26
Dalí, *The Secret Life*, p.170.

27
It is revealing that Dalí chose to project this precise detail in a lecture at the Sorbonne, Paris, on 17 December 1955.

28
On Dalí and Lorça, see Ian Gibson, *The Shameful Life of Salvador Dalí*, London 1997.

29
On Dalí and Gradiva, see Fiona Bradley's essay in this catalogue. Jensen's novel and Freud's study of it were published together in French in 1931. Some time afterwards, Paul Eluard wrote to Gala 'J'espère que tu as bien reçu Gradiva' indicating that Dalí probably acquired the book from this source. Paul Eluard, *Lettres à Gala 1924–1948*, ed. Pierre Dreyfus, Paris 1984, p.248.

30
Freud, *On Narcissism: An Introduction*, p.88.

31
Kristeva, *Tales of Love*, p.125.

32
This is merely put forward as a speculation acknowledging that Dalí's Catholic imagery mostly comes after this date. Interestingly, Nicolas Poussin used a pieta by another artist as a source image for the dead Narcissus in his *Echo and Narcissus* (1629–30), Musée du Louvre, Paris.

33
Sigmund Freud, 'The "Uncanny"' (1919), *PFL* , vol.14, p.356.

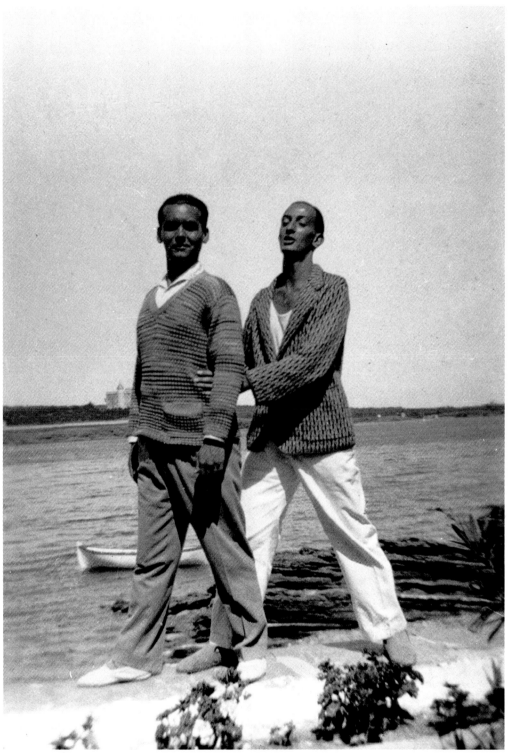

Photograph of Salvador Dalí and Federico García Lorca in Cadaqués
Fundación Federico García Lorca

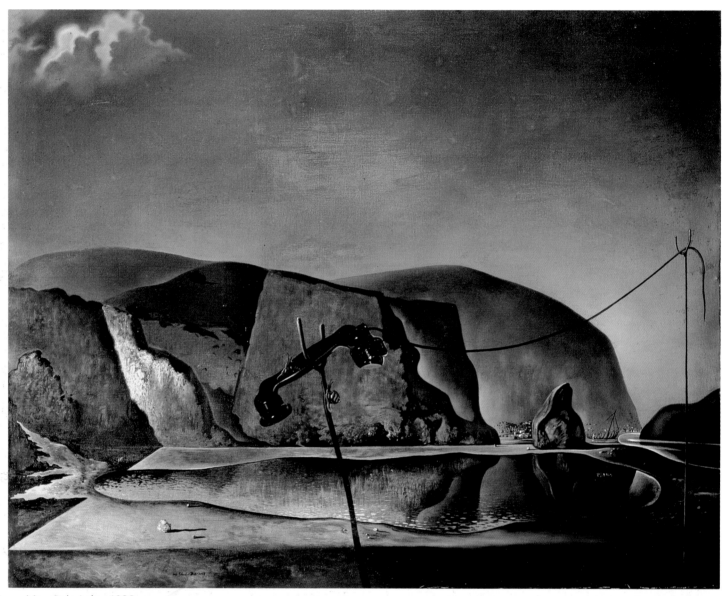

36 *Mountain Lake* 1938
Tate Gallery, London

Dalí responded to the threat of war in the 1930s with paintings of cannibalism, mythological monsters and telephones. The telephones are often cracked or have had their cords snapped, grotesque symbols of broken communication and betrayed political promises. Despite Hitler's oppressive regime, Dalí did not quite see him as a father figure in the William Tell or Lenin mould, but rather as a feminised masochist. *Mountain Lake* is an elegant double image, the lake being readable also as a fish.

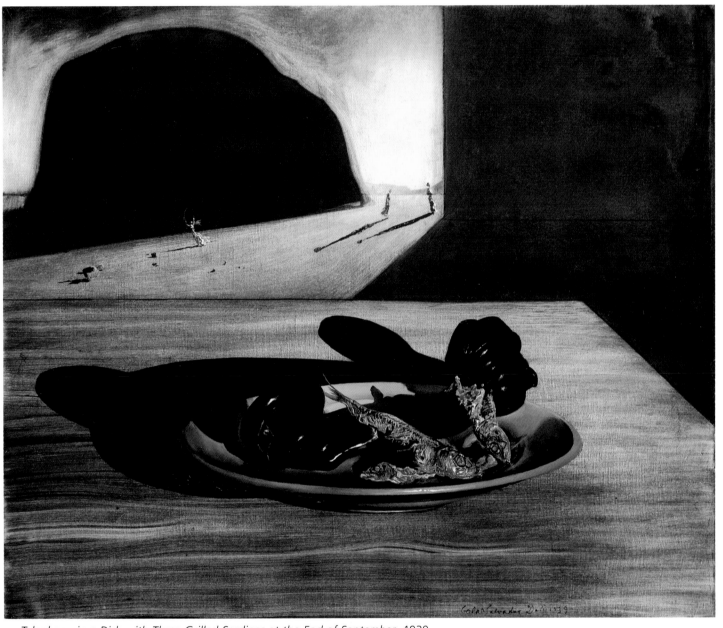

41 *Telephone in a Dish with Three Grilled Sardines at the End of September* 1939
Salvador Dalí Museum, Inc., St Petersburg, Florida

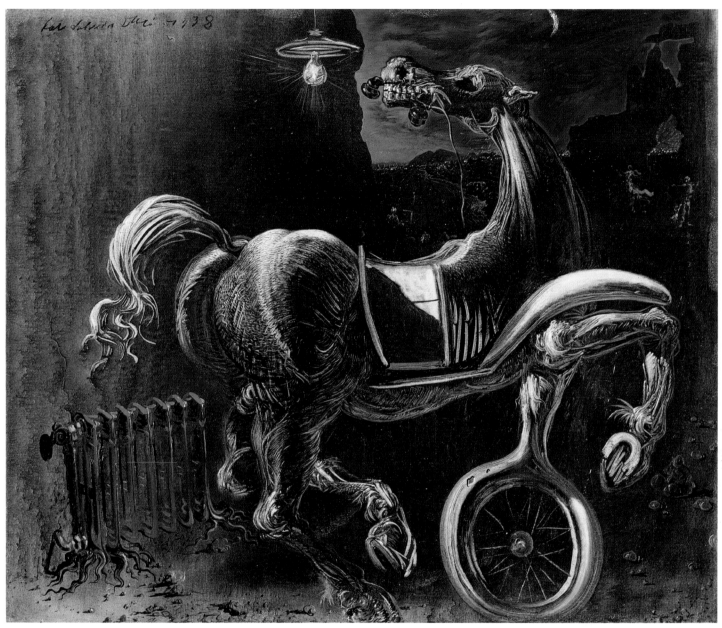

35 *Debris of an Automobile Giving Birth to a Blind Horse Biting a Telephone* 1938
The Museum of Modern Art, New York, James Thrall Soby Bequest, 1979

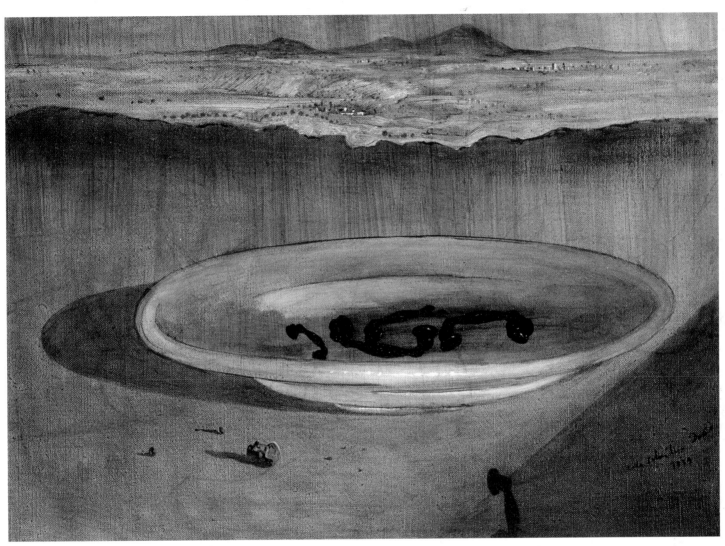

39 *Landscape with Telephones in a Dish* 1939
Courtesy Helly Nahmad Gallery, London

Salvador Dalí: Portrait of the Artist as (An)Other

Robert S. Lubar

'At the age of six I wanted to be a cook. At seven I wanted to be Napoleon. And my ambition has been growing steadily ever since.'[1] With these famous words Salvador Dalí, self-proclaimed genius and defender of tradition against the 'sticky and retarded Kantians of scatalogical *sections d'or*,'[2] enters into an elaborate game of cat and mouse in his extravagant autobiography of 1942. *The Secret Life of Salvador Dalí* claims to be a revelatory text, mapping the course of Dalí's spectacular ascent to fame across a fertile landscape of reminiscences, anecdotes, literary excurses, and screen memories. Dalí's tone remains unabashedly confessional throughout – the book pretends to 'tell all' – and the reader is privy to the artist's most intimate secrets, phobias, phantasies, and perversions. 'Unspeakable confessions',[3] as the title of a later autobiographical tract reads; the talking cure of psychoanalysis.

With the notable exception of David Vilaseca,[4] Dalí's critics have either taken his excursions into the realm of autobiography at face value or have dismissed his prose as a capricious and cynical exercise in self-promotion. These judgements represent a serious failure to reckon with the ways in which the artist actively established and simultaneously dislocated the myth of a unitary subject of autobiography and self-portraiture in his literary and visual corpus. Dalí's identity, alternately substantiated and undermined by the artist himself, is a phantom and mobile presence, the unstable condition of what Vilaseca aptly terms 'the apocryphal subject'. Although Dalí liked to remind his public that the only difference between himself and a madman is that he was not mad – suggesting that he both accepted and denied full responsibility for the production of his self-image[5] – his oeuvre can also be understood as an exploration of the self as 'other'.

Dalí's attempts at literary autobiography and the establishment of a myth of himself find a parallel in the numerous self-portraits he produced throughout his long career. To speak of self-portraiture in Dalí's work is, of course, redundant, as Salvador Dalí, the man, the artist, and the personality remain the subject and object of his life's work. Nevertheless, the ontological status of self-portraiture as a particular kind of psychic production is an issue that requires considerable elaboration. For Dalí's self-portraits are not so much premised on resemblance as they are on the simulated effects of masquerade. From the artist's early *Self-Portrait with the Neck of Raphael* (1920–21), in which Dalí traces the palimpsest of a modern dandy upon the art historical ground of a self-portrait by the Italian master, to the

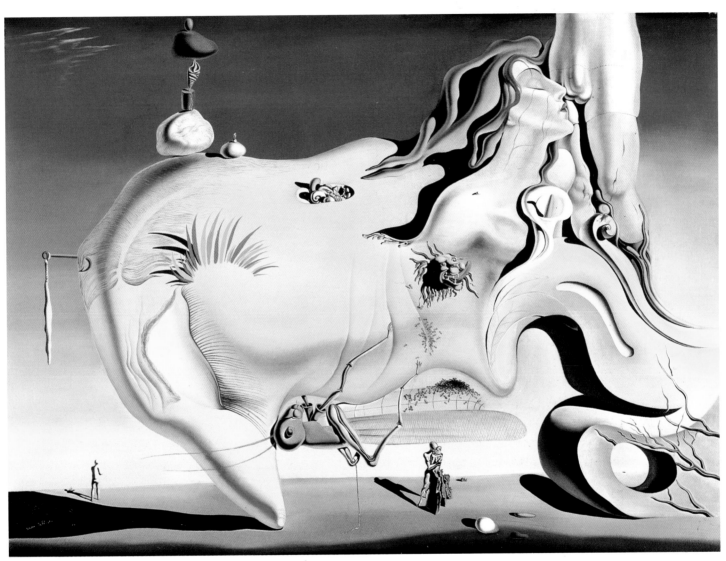

The Great Masturbator 1929
Museo Nacional Centro de Arte Reina Sofía, Madrid

celebrated *Cubist Self-Portrait (Self-Portrait with La Publicitat)* of two years later, in which Dalí's schematically rendered face is suspended in a grid-like lattice, the mask at once assumes a figurative and symbolic valence. Like the anamorphic self-portraits that make an appearance in Dalí's notorious Freudian dreamscapes of 1929 – *The Great Masturbator, The Lugubrious Game and Illumined Pleasures* – the artist positions the imaginary self in relation to another, trapped in a hall of mirrors and locates the speaking subject at an angle to the unconcious. In place of the unitary, self-identical subject of idealist philosophy, Dalí sketches the fluid contours of the 'polymorphous perverse',[6] a decentred subject who is supported by a symbolic code vulnerable to penetration from within and without: the subject, as it were, of *Soft Self-Portrait with Fried Bacon* (1941). To view Dalí – the artist and the man – in this way, to see him through the reflection of his own distorting mirror, is to affirm that the subject of self-portraiture is in fact the object of an elaborate masquerade.

At every turn, Dalí's work challenges the traditional, physiognomic function of portraiture as a tacit agreement between the painter and the sitter that an authentic self will be secured in representation. As Richard Brilliant observes:

> The careful examination of a portrait of oneself, or of another, should expose the particular dialectic of portraiture most acutely, as the viewer confronts the purposeful relationship between the original, who presents himself or herself *in* the world, and the portrait as a subsequent representation of that person. Thus, self-representation and artistic representation come together in the singular portrait image, but often uneasily.

This last observation is important, for a wide range of devices and signifying marks mediate the scopic encounter between artist and sitter, bridging the gap between object viewed and object painted: conventional portrait types, social attributes, textual descriptions, prior representations of the sitter, etc. The sitter not only presents himself or herself in the world, as Brilliant remarks, but presents him/herself *to* the world; that is to say, he or she is actively involved in performing his/her own portrait.

One may thus posit a three-way transaction between artist, sitter, and image which locates the subject at the centre of the scene of representation, as a condition of representation. Portraits are never physiognomic imprints or indexes of authentic being in a direct, unmediated sense, but are projections of and investments in ego ideals through which the self is affirmed as an authentic and unique being. To speak of portraiture is to speak of a dual process of identification and alienation, a dialectic of self and other that is staged in the realm of what the French psychoanalyst Jacques Lacan calls 'the Imaginary'. In the case of

17 *Memory of the Child-Woman* 1932, detail
Salvador Dalí Museum, Inc., St Petersburg, Florida

Imperial Monument to the Child-Woman c. 1929, detail
Museo Nacional Centro de Arte Reina Sofía, Madrid

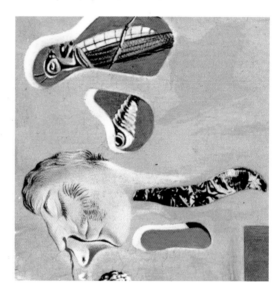

Illumined Pleasures 1929, detail
The Museum of Modern Art, New York.
The Sidney and Harriet Janis Collection

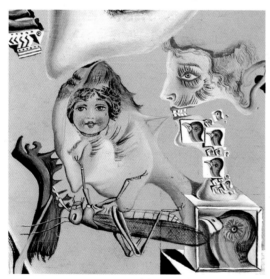

4 *The First Days of Spring*
1929, detail
Salvador Dalí Museum,
Inc., St Petersburg, Florida

Anamorphic self portrait masks appear in Dalí's paintings from 1929. The shape of the face, usually presented resting on its nose, is strongly reminiscent of one of the rock formations of the coastline near Dalí's home. Occasionally appearing alone, the self-portrait mask is more usually surrounded with other Dalinian iconography relating to his image of himself, most notably the grasshopper which so often takes the place of the face's mouth.

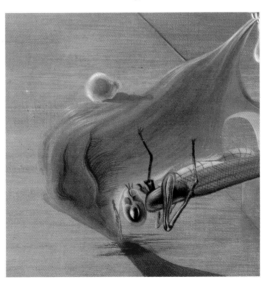

5 *Phantasmagoria* 1929, detail
J. Nicholson, Beverly Hills, California

24 *Study for 'Portrait of the Vicomtesse de Noailles'* 1933
Salvador Dalí Museum, Inc., St Petersburg, Florida

self-portraiture, the stakes are raised as this dialectical relationship presupposes a split within the artist-sitter's identity as a unitary subject: the image viewed in the mirror is in fact an alien presence that returns its gaze to the viewing subject. To borrow Arthur Rimbaud's felicitous phrase: 'Je est un autre' – 'I is another'.[8]

Dalí and Lacan engaged in a brief but productive exchange of ideas in 1933.[9] Dalí's early readings of Freud, particularly *The Interpretation of Dreams*,[10] and his own work on the structure of paranoia already predisposed him to the view that the unconscious is structured like a language in a field of pure alterity, as Lacan would later theorize.[11] If language, in Lacan's view, is an opaque screen of signifiers through which experience is mediated and symbolically coded, Dalí constructs his autobiography on the grounds of what he calls 'false memories' in order to expose the very workings of that code and the inherent instability of subject positions.

In the 'Anecdotic Self-Portrait' with which Dalí begins his narrative in *The Secret Life*, the artist selectively recounts his first meeting with the psychoanalyst. Speaking in the first person, Dalí describes his anxious anticipation of Lacan's arrival to his studio on the Rue Gauguet in Paris:

> I continued working from memory on the portrait of the Vicomtesse de Noailles on which I was then engaged. This painting was executed directly on copper. The highly burnished metal cast mirror-like reflections which made it difficult for me to see my drawing clearly. I noticed as I had before that it was easier to see what I was doing where the reflections were brightest. At once I stuck a piece of white paper half an inch square on the end of my nose. Its reflection made perfectly visible the drawing of the parts on which I was working.

Lacan arrives at the appointed time and the two men converse 'in a constant dialectical tumult'. Upon Lacan's departure, Dalí continues:

> I paced up and down my studio, trying to reconstruct the course of our conversation… But I grew increasingly puzzled over the rather alarming manner in which the young psychiatrist had scrutinized my face from time to time. It was almost as if the germ of a strange, curious smile would then pierce through his expression. Was he intently studying the convulsive effects upon my facial morphology of the ideas that stirred my soul?

Moments later, when the artist gets up to wash his hands, he discovers the reason for his colleague's unsettling gaze: looking at his reflection in the mirror, Dalí realises he had forgotten to remove the white paper from the tip of his nose.[12]

To dismiss this amusing anecdote as an apocryphal story would, of course, be to miss the complex ways in which Dalí views an historical event – his actual meeting with Dr. Lacan – through a prism that reflects his psychoanalytic understanding of the subject of portraiture itself, the latent content, one might say, of the 'Anecdotal Self Portrait' and of *The Secret Life* as a whole. To be sure, Dalí sketches the portrait of a scopic encounter between two men which is charged with admiration and anxiety. The voice of the speaking subject – Dalí in the first person – serves to anchor the ego's sliding identifications. That this entire anecdote is staged in relation to Dalí's work on a portrait painting underlines the fact that the subject of the anecdote is the dialectic of self and other.

Now, Lacan positions portraiture along the Imaginary axis of identificatory relations. In what he describes as the Mirror Stage of psychic development – the phase of primary narcissism – the child moves beyond identification with the mother and enters into a dual, imaginary relationship with an ideal self, located outside his body – metaphorically, in the reflected, ideal image of his double in the mirror. This immediate relation of self to self is overcome through the appearance of a third, mediating term through which the child constructs him/herself in language as the differentiated subject 'I'. It is through the 'paternal metaphor' – the Oedipal interdiction – that the child ultimately gains access to the Symbolic order of language and assumes his position in the family as a gendered, social subject. But this relationship also alienates the subject from the direct apprehension of lived experience, which, according to Lacan, is repressed through symbolisation. Being born into the symbolic order of language, then, presupposes a fundamental division, or split, within the subject,[13] such that the speaking subject is a being-in-alteration, suspended between the imaginary axis of identification and the symbolic axis of language. In Lacan's view, discourse is never a direct transaction between a subject and an object (other) but is the function of an inter- and intrasubjective dialectic.

In Dalí's anecdote, the washing of the hands following the encounter with Lacan, and the status of the little piece of white paper on the tip of the artist's nose, actually serve to place the history of the subject 'Salvador Dalí' within a psychoanalytic grid, thereby exposing the autobiographical 'truth' of *The Secret Life* as an elaborate ruse. In his 1927 essay on fetishism, Freud presented the case of a young man who, owing to a confusion between two similar terms – the German word 'Glanz' (shine) and the English word 'glance' (in the sense of a furtive 'look' or 'gaze') – fetishizes a 'shine on the nose' of a woman. The confusion is ultimately revealed to be a form of linguistic displacement in which 'shine on the nose' replaces 'glance at the nose', the fetish object which Freud theorizes is a memorial to castration in the dual sense of the subject's recognition and disavowal of the lost maternal phallus.[14] But, as Hal Foster remarks, the fact that the condition of loss is figured in the

Still from *Un Chien andalou* 1929

form of the analysand's gaze opens the scenario of castration to yet another reading in which the gaze is somehow external or alien to the subject, representing a loss that prexists him as a speaking subject.[15] This gaze, what Lacan would call le regard, is constituted in relation to the experience of subjectivity as lack-in-being: the gaze that enables us to 'see' in our dreams or, as Lacan would have it, to see on the field of the (unconscious) Other.[16]

Dalí repeatedly figured this gaze in his art and writings: most notably, in the horrific opening sequence of Un Chien andalou (1929), in which a razor blade bisects a woman's eye, blinding her in an act of symbolic castration. In Illumined Pleasures of the same year, two hands wielding a bloody knife in the lower left foreground thematize the transgression of the oedipal interdiction that is staged throughout the painting.[17] Whether this refers specifically to Dalí's growing affections for Gala Eluard in the summer of 1929, which his father condemned, or offers itself to a more generalised interpretation, the primal scene figures as a moment of separation and loss overshadowed by the threat of paternal retribution.[18] By equating symbolic castration with the threat of emasculation in Illumined Pleasures, Dalí paints a frightening picture of the price one must pay for subjectivity.

In this light, the meeting with Lacan is open to a second interpretation of the psychoanalytic subject of self-portraiture in Dalí's autobiographical narrative. The washing of the hands – the ultimate guilty gesture signifying a symbolic trespass against the father – occurs within a scenario that already encodes the 'shine on the nose' as a figure for the recognition/ disavowal of loss and separation from the mother. That Dalí recognises the dual threat of his own emasculation (which is simultaneously disavowed in relation to the fetish object) and the possibility of paternal retribution for failing to accede to the Oedipus is suggested by the fact that he is blinded (blindness here functions as a cypher for symbolic castration) by the mirror-like reflections cast by the brilliant copper plate on which he paints a portrait of the Vicomtesse de Noailles (a woman, to be sure). Dalí's position as a subject – indeed, as the subject of Illumined Pleasures and The Secret Life – is thus revealed to be inherently unstable. But there is also a second mirror relation that threatens to unhinge Dalí, to unbind his ego, as it were. This is the tremendous psychic tension that casts a shadow over his entire meeting with Lacan. Just as the articles on the structure of paranoia that Dalí and Lacan each published in the May 1933 issue of Minotaure[19] reflect similar theoretical positions – 'We were suprised to discover that our views were equally opposed, and for the same reasons, to the constitutionalist theories then almost unanimously accepted', Dalí informs the reader[20] – it is not hard to imagine that the meeting of minds between two men of roughly the same age (Lacan was three years Dalí's senior) and intellectual disposition contained elements of (mis)recognition, resistence, and aggression alike. In the 'Anecdotal Self-Portrait'

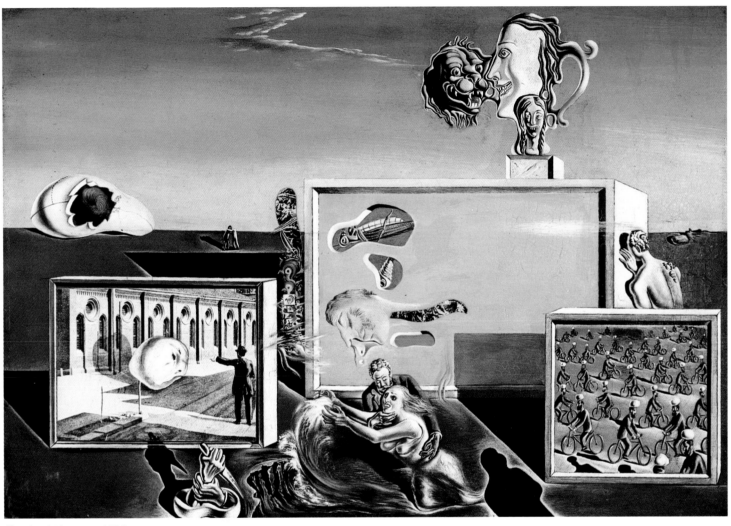

Illumined Pleasures 1929
The Museum of Modern Art, New York. The Sidney and Harriet Janis Collection

Lacan represents Dalí's mirror image, the double through which the artist enters into a narcissistic relation of proximity that threatens his position of mastery as a speaking subject, the unitary 'I' of autobiography and self-portraiture. Sliding between the 'I' and the Other, the Ego and its objects, Salvador Dalí emerges as a subject in *potentia*.

Notes

1
Salvador Dalí, *The Secret Life of Salvador Dalí*, St. Petersburg, Florida 1986, p.1.

2
Salvador Dalí, 'The Abject Misery of Abstraction-Creation', in Salvador Dalí, *Conquest of the Irrational*, NewYork 1935, p.19.

3
Salvador Dalí, *The Unspeakable Confessions of Salvador Dalí*, London 1976.

4
David Vilaseca, 'The Apocryphal Subject: Masochism, Identification, and Paranoia in Salvador Dalí's Autobiographical Writings', Vol.17, *Catalan Studies: Translations and Criticism*, ed. Josep Solà-Solé, New York 1995.

5
In a duplicitous statement calculated to bridge the gap between the paranoid, guilty subject and the literary subject of fiction, Dalí affirms in *The Secret Life*, p.6: 'One thing, at least, is certain: everything, absolutely everything, that I shall say here is entirely and exclusively *my own fault.*'.

6
Salvador Dalí, *The Secret Life*, p.2.

7
Richard Brilliant, *Portraiture*, Cambridge, Massachusetts 1991, p.46–47.

8
Artur Rimbaud, letter to Paul Demeny, 15 May 1871 in Wallace Fowlie, *Rimbaud: Complete Works, Selected Letters*, Chicago and London 1966, p.302.

9
For an historical account of Dalí's meeting with Lacan, see Elisabeth Roudinesco, *Jacques Lacan. Esquisse d'une Vie, Histoire d'un Système de Pensée*, Paris 1993, p.56-57, 85.

10
Sigmund Freud, *La Interpretación de los Sueños*, Madrid 1923. The Spanish translation of Freud's text coincided with Dalí's stay at the Residencia de Estudiantes in Madrid.

11
Patrice Schmitt, 'De La Psychose Paranoïaque dans Ses Rapports avec Salvador Dalí,' in *Salvador Dalí Rétrospective: 1920–1980*, exh. cat., Musée National d'Art Moderne, Centre Georges Pompidou, Paris 1980, p.262–266. Lacan had been preparing his doctoral thesis on paranoia ('De la Psychose Paranoïaque dans ses Rapports avec la Personalité,' 1932) and was initially impressed with Dalí's text *L'Ane Pourri*, which appeared in *Le Surréalisme au Service de la Révolution*, No.1, July 1930. Through the intercession of André Breton, Lacan was able to arrange for a meeting with the artist. In the prologue to Dalí's 'Nouvelles Considérations Générales sur le Mécanisme du Phénomène Paranoïaque du Point de Vue Surréaliste', in *Minotaure*, No.1, May 1933, p.65–67, the artist in turn asserted that Lacan's research confirmed his own findings. In the same issue of *Minotaure*, Lacan published 'Le Problème du Style et la Conception Psychiatrique des Formes Paranoïaques de l'Expérience.' A careful examination of Dalí's writings in the four year period between 1929 and 1933 suggests that Dalí had, in fact, begun to work out his theory of paranoia-criticism independently, although his ideas appear to have gained greater theoretical rigor in response to Lacan's work.

12
Salvador Dalí, *The Secret Life*, p.17–18.

13
As Anika Lemaire, *Jacques Lacan: Écrits*, London and New York 1991, p.53, explains: 'This disjunction will become greater over the years, language being above all the organ of communication and of reflection upon a lived experience which it is often not able to go beyond. Always seeking to "rationalize," to "repress" the lived experience, reflection will eventually become profoundly divergent from that lived experience. In this sense, we can say... that the appearance of language is simultaneous with the primal repression which constitutes the unconscious.'

14
Sigmund Freud, 'Fetishism', 1927, in *The Writings of Sigmund Freud: Standard Edition*, Vol.21.

15
Hal Foster, 'The Art of Fetishism: Notes on Dutch Still Life,' in *Fetishism as Cultural Discourse*, ed. Emily Apter and William Pietz, Ithaca and London 1993, p.251–265.

16
Jacques Lacan, *Séminaire XI. Les Quatre Concepts Fondamentaux de la Psycho-Analyse. Texte Établie par Jacques-Alain Miller*, Paris 1973.

17
The knife serves a dual function here, alluding to castration and the literal 'cuts' that are figured in Dalí's discrete incorporation of collage elements in the painting.

18
In this scenario, the older man who grabs the young woman in an ejaculatory and threatening embrace in the centre foreground (note the waves of passion to the couple's left) is a symbolic substitute for Dalí, who assumes the rights and privileges of the father. His fear of retribution for usurping the authority of the father is in turn figured in the image of the young man who hides his head in shame (left centre of the painting). The image of paternal authority itself is present in the form of a lion's head presiding over the scene. Dalí's self-portrait appears above the couple.

19
See note 14.

20
Salvador Dalí, *The Secret Life*, p.18.

51 *Portrait of Laurence Olivier in the Role of Richard III* 1955
Perrot-Moore Art Centre, Cadaqués

Shades of Darkness: Mythology and Surrealism

Jennifer Mundy

> Follow, without asking anything, the person in our group who will be waiting
> for you on the road. Follow in groups of two or three at the most and in silence,
> until you see the path, from which point the walk will take place in single file,
> each a few metres behind the one ahead…
>
> Once at the meeting place, stop and wait to be conducted individually
> to the place where you must stay still and silent until the end…
>
> On a marshy soil, in the centre of a forest, where turmoil seems to have
> intervened in the usual order of things, stands a tree struck by lightning.
> One can recognise in this tree the mute presence of that which has assumed
> the name of Acéphale, expressed here by these arms without a head… This
> ENCOUNTER which is attempted here will take place in reality to the degree
> that death will appear.[1]

These words come from a set of instructions written by the prominent author and philosopher, Georges Bataille, sometime in the late 1930s for the initiates of a secret society named Acéphale. This secret society had been set up by Bataille around 1936 as an attempt to create a small quasi-religious sect or community, bound together by a common acceptance of myth and secret rites. It was dedicated to the exploration of the sacred, which for Bataille, as for Friedrich Nietzsche – whose writings Bataille admired enormously – entailed acceptance of the darkest sides of human nature. There was no place for the Christian religion or any idea of God or morality. Initiates were, in Bataille's words, to 'abandon the world of the civilised and its light', and instead to 'seek out and to confront a presence that swamps our life of reason', to 'part the veil with which our own death is shrouded'.

Exactly what took place at the society's meetings, held at night around this 'headless' tree in the forest of Saint-Nom-la-Bretèche, to the west of Paris, and elsewhere, remains unclear. However, on at least two occasions Bataille seems seriously to have entertained the idea of human sacrifice in a bid to probe and confront the primitive passions associated with death and killing. One of the members of the group and a former surrealist, Roger Caillois, recalled an instance when a willing victim had been found but that no one was willing to be

André Masson
Drawing for the cover of *Acéphale* 1937

the executioner. Another member, Patrick Waldberg – a political activist associated with surrealist circles – remembered that at the last meeting, held in the autumn of 1939, Bataille asked, in vain, for an initiate to volunteer to be put to death, 'since this sacrifice would be the foundation of a myth, and ensure the survival of the community'.[2]

Acéphale certainly represents an extreme manifestation of contemporary fascination with myth. However, Bataille's belief that human society needed to recover a sense of the mythic if it were to overcome its modern propensity to anomie and atomisation, and become organically integrated and spiritually fulfilled, was one that was widely shared by French, and indeed European, intellectuals in the 1930s. Developments in anthropological, sociological and psychoanalytical thought, and the emergence of new political systems that set out to mobilise the masses through a deliberate exploitation of the irrational, the primitive, the instinctive and the inhumane, had made myth into one of the most compelling subjects of the decade, and few avant-garde artists or writers in this period were able to ignore contemporary thinking about the ways in which the individual was bound to the collective.

The subject of myth was particularly pertinent to Surrealism, which aimed both to liberate the individual and change society. Seeking to create a new, modern mythology, the poets of the group imitated mythological narratives: in such texts as André Breton's *Nadja* (1928) or Louis Aragon's *Le Paysan de Paris* (1924), portents were divined in everyday situations, and places were invested with quasi-magical significance. For such surrealist artists as Dalí, Max Ernst and André Masson, myths, whether classical or newly invented, provided a store of images with which to address profound, and normally repressed, aspects of the human psyche. However, myth was something of a two-edged sword. In seeking to use myths, and in particular those ancient myths that touched on the darker sides of human nature, to free the individual from the trammels of rationalist convention, the surrealists found themselves in the 1930s using the same currency as their political opponents – those on the right who were employing myth to underpin the dissolution of the individual in the collective will and life of the community. Dalí's expulsion from the movement in the mid-1930s for his refusal to disavow fascism may be seen as a symptom of the tensions arising from the inherently ambivalent path along which the surrealists had been drawn by myth.

From the Renaissance to the late nineteenth century, myths of the classical world had provided a rich source of images and narratives. Ancient Greece in particular was viewed in arcadian terms as a place of light, love, sensuality, harmony and reason. It was the land of Plato and Aristotle, Pericles and Phidias. However, in the late nineteenth century, thanks in part to the excavations of Schliemann, a new sense of the historical reality of the pre-classical period began to emerge. Views of ancient Greece began to change; and it came

to be seen by scholars less as the cradle of western civilisation and more as a fundamentally pre-modern, primitive world. The first signs of the new understanding of the classical world were found in the writings of Friedrich Nietzsche, one of the most influential thinkers of modern times. In 1872 Nietzsche, then a young professor of classical philology at Basle, published *The Birth of Tragedy*, a book that helped transform perceptions of the ancient world. In contrast to the prevailing view that saw Greek art as embodying 'noble simplicity, calm grandeur', Nietzsche claimed that in Greek culture – and in the human soul – there were two opposing tendencies which he described as Apollinian and Dionysian. The first embodied qualities of restraint, measure and harmony. The second – and most fundamental – involved an unleashing of savage instincts, and an intoxicated sense of oneness with nature. Both these tendencies, he argued, had been necessary for the creation of the great Greek tragedies. The tragedies lost their emotional and artistic power when the Apollinian element gained the upper hand, when the old myths were no longer experienced as part of a sacred ritual but became the subject of rational analysis. 'Without a myth', he wrote in *The Birth of Tragedy*, 'every culture loses its healthy, creative natural power. Only a horizon enclosed by myths gives unity to a whole cultural movement.'[3] This thin volume, unburdened by footnotes or classical references, was swiftly attacked for its lack of scholarship; but the central intuition underlying it was to be taken up by later classical scholars. F.M. Cornford, a British classicist, later wrote that *The Birth of Tragedy* was 'a work of profound imaginative insight, which left the scholarship of a generation toiling in the rear'.[4]

In the early years of this century, classical studies were invigorated thanks to the new discipline of anthropology. The key figure here was Sir James Frazer, whose masterpiece *The Golden Bough*, published in twelve volumes between 1890 and 1915 and translated into many languages, had an enormous impact on a generation of intellectuals. This work sought initially to explain the rituals and legends associated with a specific ancient cult; but through digressions and cross-referencing it developed into a massive general study of primitive societies, ideas and practices. Behind Frazer's comparative approach lay a belief in the 'essential similarity with which, under many superficial differences, the human mind has elaborated its first crude philosophy of life'.[5] His cross-cultural approach appeared to open unknown vistas in the interpretation of Greek religion and the myths and rituals that accompanied it. As one reviewer of the history of approaches to myth has written, the disparate and often incoherent store of information about Greek myths and rituals found in the writings of ancient authors was ransacked by a new generation of classical scholars 'to provide supporting evidence for intuitions about scapegoats, fertility-spirits, year-demons, and sacred marriages, as well as mana, orenda, totem, taboo, and all those fascinating new concepts whose authority seemed to stretch from Polynesia and Peru to the Acropolis at Athens itself'.[6] In the early decades of this century the study of myth in ancient and

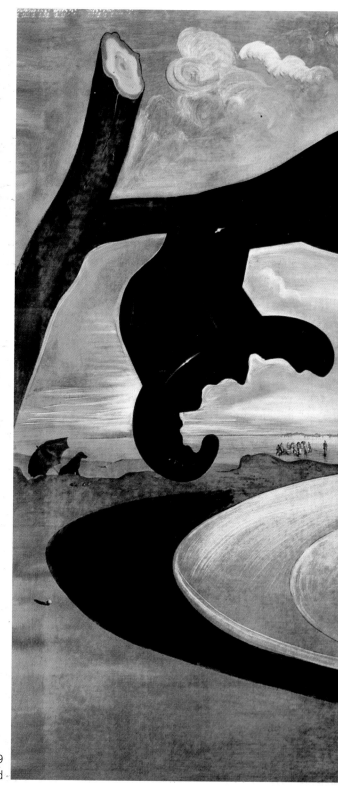

38 *The Enigma of Hitler* 1939
Museo Nacional Centro de Arte Reina Sofía, Madrid

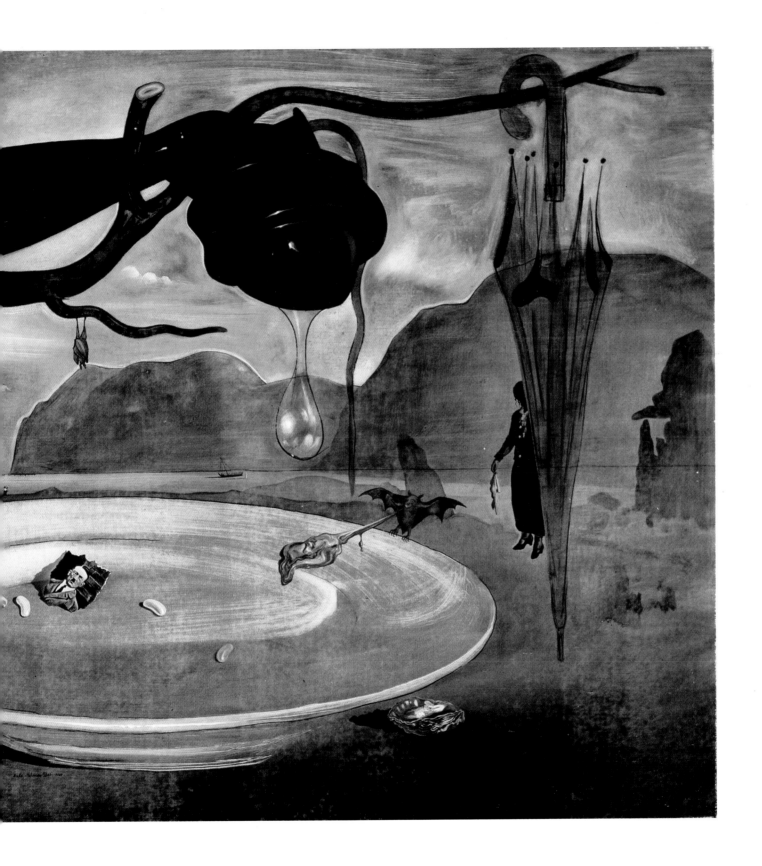

primitive societies was taken forward in such works as *The Myth of the Birth of the Hero* (1909) by Otto Rank, *Tsimshian Mythology* (1916) by Franz Boas, and Bronislaw Malinowski's classic texts, *Argonauts of the Western Pacific* (1922) and *Myth in Primitive Psychology* (1926). In the same period scholars of the so-called Cambridge School of Classical Studies combined the approach initiated by Frazer with a belief in a 'primitive mentality', reflecting the ideas of the French writers Emile Durkheim and Lucien Lévy-Bruhl.

Classical mythology was given another new dimension of meaning through the insights and intuitions of Sigmund Freud, founder of the discipline of psychoanalysis. Freud was fascinated by the ancient world, and frequently drew comparisons between the work of the psychoanalyst in exposing suppressed memories and experiences and that of the archaeologist in discovering buried material belonging to lost civilisations. In 1892 he wrote of his own findings, 'I hardly dare believe it yet. It is as if Schliemann had again dug up Troy, which before him was a myth'. Not surprisingly, perhaps, he turned to classical examples to illustrate and validate his ideas about human psychology. He recognised the expression of the Oedipus complex in Sophocles' famous drama; the Electra complex in the story of Agamemnon's daughter; and narcissism in the myth of Narcissus.[7] Of course, his interest in mythical thought was not restricted to classical examples. In *Totem and Taboo*, first published in 1912–13, Freud looked at the psychological structures surrounding the universal prohibition on incest and the practice of totemism in primitive societies. Drawing factual material from the published researches of such anthropologists as Frazer, Freud theorised that the origins of these institutions in primitive societies could be traced back to a real, and then ceremonialised, slaying of the father by his sons. In the Oedipal relationship of the son and the father lay, Freud claimed in this much acclaimed book, 'the beginnings of religion, morals, society and art'.[8]

The intellectual excitement provided by such new disciplines as anthropology and psychoanalysis coincided with the emergence in the arts of modernism; and in what was often a curious mixture of reverence and irony – reverence for the canon of western art, and yet, through irony, an attempt to break with it or redefine it – myth, particularly classical myth, was transformed into a kind of personal vocabulary with which to comment on human nature and society, or, more importantly, to explore the individual psyche. The case of the two leading modernist writers of the early twentieth century is here instructive. T.S. Eliot, in *The Waste Land*, published in 1922, drew on a wide range of myths – the Grail legends of the Middle Ages, the 'vegetation ceremonies' described by Frazer in *The Golden Bough*, the stories of Tiresias and Philomela in Ovid's *Metamorphoses* – in his attempt to come to terms with his acute personal problems and what he saw as the spiritual desert of the post-War world. James Joyce, in his novel *Ulysses*, published in Paris in the same year, reworked the

Max Ernst
Oedipus Rex 1922
Private Collection, Paris

Photograph by Serge Lido of the staging of the opera-oratorio *Oedipus Rex*
1927 by Cocteau and Stravinsky.

story of the Odyssey (which he described as 'the most beautiful, all-embracing theme… greater, more human than Hamlet, Don Quixote, Dante, Faust') to create a highly idiosyncratic work whose scale, allusive style and extraordinary combination of realism and fantasy were an attempt to transform the banality of everyday modern life into a contemporary epic, as mythic and poetic as its Greek precursor.

In France in the years immediately following the appalling devastation of the First World War a climate of political conservatism set in which helped to fuel an overtly traditional, essentially Apollinian, approach to the classical world. This was the period of the 'return to order' (a phrase coined by the fashionable playwright and artist Jean Cocteau). Consciously distancing themselves from elements of their own pre-War avant-garde work (criticised by some as 'foreign' in character), artists as diverse as Picasso, Derain, Léger and Le Corbusier explored different aspects of classicism. Their work was varied and open to modernist inter-pretation, but nonetheless shared a vision of the ancient world as a light-filled arcadia, and presented classicism as allied to, and often synonymous with, harmony, order and restraint.

The surrealists, however, had no truck with the classical revival nor with the chauvinism associated with it. 'We take this opportunity to dissociate ourselves publicly from all that is French, in words and in actions', a tract of 1925 declared. 'Greco-Roman classicism, we abandon you to your infamous sanctimoniousness.'[9] The movement saw itself as revolution-ary, and found the elitist and conservative connotations of the 'return to order' repellent. One reason for the surrealists' enmity towards Cocteau (who was among the first at this time to explore the dream-like and sometimes dark side of classical myth, for example, in the play *Orpheus,* 1925 and the opera-oratorio *Oedipus Rex,* 1925–7), was the fact that he was closely linked with rich and fashionable people. However, as the artists of the movement recognised earlier than the writers, myths did not simply have to be classical myths: they could encompass a broader range of themes and subject matter, and allow an exploration of the mechanisms whereby individuals and societies expressed their feelings and values. For a movement dedicated to uncovering the deeper recesses of the mind, the subject of myth was too important to be ignored.

In the 1910s and 1920s the Italian artist Giorgio de Chirico used myth to express his profound love of the ancient world and to address mysterious emotions and feelings, which, in ways that he was perhaps only partly aware of, had their origins in his childhood. Like many of his background, de Chirico received a strongly classical education, and the fact that he spent the early part of his life in Thessaly, in Northern Greece, made the ancient world seem particularly real and poignant to him. Significantly, his dream-like classical imagery was fuelled not by direct observation but by memories and nostalgia: he began to explore

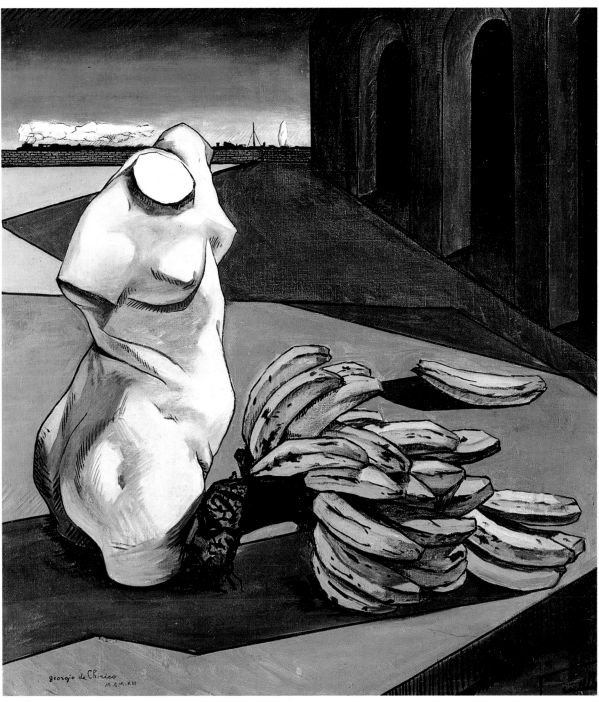

Giorgio de Chirico
The Uncertainty of the Poet 1913
Tate Gallery, London

and develop classical themes when distant from Greece and Italy, first in Munich in 1908–10 and in Paris in 1911–15. In Germany, de Chirico discovered the brooding paintings of the Romantic Swiss artist Arnold Böcklin, and the 'strange and deep poetry' of Nietzsche. The latter's description of the strange, melancholic atmosphere of autumnal afternoons in Italian cities, particularly Turin, was the inspiration for de Chirico's scenes of semi-deserted piazzas and shaded arcades.

During the War years de Chirico and his brother, known by the professional name Alberto Savinio, developed a private mythology, in which they referred to themselves as Argonauts, alluding to the fact that the mythological heroes were supposed to have set sail from the town in Thessaly where the two brothers had grown up, and to their perception of them-selves as voyagers into the unknown; and myth became an increasingly prominent element in the work of both. Savinio went on to develop mythical imagery relating to the beginnings of the world in his paintings of Titans and, in a modern vein, of brightly coloured 'toys'. For his part, de Chirico painted himself as Odyseus in 1924, and focused on the theme of the father-son relationship using the Biblical story of the Prodigal Son.

De Chirico exerted a powerful influence on one of the most important figures in the surrealist movement, Max Ernst. In his autobiographical notes Ernst gave a short and striking account of his experience of the First World War: 'Max Ernst died on the 1st of August 1914. He was resuscitated the 11th of November 1918, as a young man aspiring to become a magician and to find the myth of his time.'[10] The effect of the War, in which he served in the German artillery, was to make him re-examine the values of modern society, and to seek, as one commentator has noted, 'a structure of thought and imagery that would enrich and make sense of his own time and place'.[11] Ernst had first read Freud in 1911 while studying philosophy and psychiatry at the University of Bonn; and after the War he began to use the myth of Oedipus to symbolise his rebellion against his father, his father's generation and his fatherland. *Aquis Submersus* (1919), takes its title from a nineteenth-century novella about an illicit liaison and the death by drowning of a son. In this painting – which marks his first extended use of dreamwork mechanisms as described by Freud – Ernst transmuted the narrative into generalised or condensed symbols, and disguised the poignancy of the story with comic elements. To furnish a neutral setting for the drama he borrowed the steep raking perspective of de Chirico's metaphysical paintings, and rendered the latter's classical architecture as toy-like rectilinear buildings. De Chirico's influence is clear, too, in one of Ernst's early major works, *Oedipus Rex* (1922). Here the reference in the painting's title to the story of the Greek hero, as related in the play by Sophocles, functions as a clue to the meaning of the work's highly complex Freudian symbolism.

14 *Diurnal Fantasies* 1932
Salvador Dalí Museum, Inc., St Petersburg, Florida

Max Ernst
Aquis Submersus 1919
Private Collection

Over the course of the 1920s Ernst's paintings became less strictly personal or autobiographical in character and alluded increasingly to generalised mythic themes. His 'forest' paintings evoked the legends associated with the forests in Germany; and his scenes of monsters arising from an inchoate mass of vegetal and animal forms suggested allusion to myths of origins. Exploiting his own distinctive bird-like profile, Ernst presented himself in his paintings in the shape of an omniscient and omnipresent bird, Loplop. This mythic creation served as a mask, allowing Ernst to control what he revealed about himself in his paintings, while evoking affinities with legends about heroes who magically assume animal form.

Myths of the ancient world lay at the core of the work of another key surrealist, André Masson: 'The Greek myths, in particular, the sombre myths of Greece', he once said, 'have always gripped me'. While mythological themes came to the fore in his work of the 1930s, his interest in the subject began much earlier. His reading of Nietzsche in 1914 had a dramatic influence on his vision of life. Equally important was his experience of the War in which, while serving in the trenches, he was critically wounded. He always said that he never physically or mentally recovered from that experience; and it seems that his wartime memories were a source of the violence of his later imagery, and of his concern to explore questions relating to the purpose of life.

Myth along with ideas of flux and metamorphosis, derived from the writings of Pre-Socratic Greek philosophers such as Heraclitus, underpinned Masson's work of the 1920s. In *The Four Elements* (1923–4), he used ancient symbolism to represent all of life, as the description by Michel Leiris, a close friend, makes clear:

> In the distance, the ocean, as a reminder of origins. Fire of the flame, air of flight, water of the waves and aquatic creatures, rotundity of the earth, the four elements are there indeed. Giving sense to it all … the indispensable human kingdom, hands occupied taking hold and letting go, distant silhouette of a desired being.[12]

André Breton, leader of the Surrealist movement, bought the work and soon after invited Masson to join it. A later painting, *The Armour* (1925), in which eroticism was linked to death, was acquired by Georges Bataille, already a close friend of the artist. Although closely related, the different emphases of the two works – hermetic symbolism, on the one hand, and a more insistent emphasis on the instinctual and the carnal, on the other – reflected something of the already divergent attitudes of Breton and Bataille.

André Masson
Mithra 1936
Collection particulière, Paris, Fond Masson

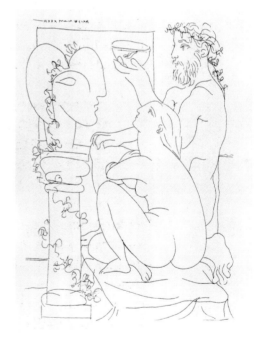

Pablo Picasso
*Sculptor with Fishbowl and Nude Seated
Before Sculptured Head* 1933

Although myth was a major theme in surrealist art of the 1920s, it was not the only one, and André Breton's approach to it was paradoxically always somewhat equivocal. On occasions he expressed interest in the surrealist potential of myth but he remained suspicious of any system of thought in which the individual was subordinated to a greater whole. He may have been fascinated by the possibilities of transcending the boundaries of the self in trances and dreams; and he was certainly deeply attracted to occult philosophies in which the individual was seen as mirroring the elements of the macrocosm; but he would not accept a vision of life which saw the individual as ultimately controlled by the instinctual or by society. His outlook was intrinsically optimistic, and it was characteristic that, as Masson later recalled, Breton would not be persuaded of the value of Nietzsche's tragic vision of man, and was always dismissive of what he described as the 'Nietzschean myth'.

Breton first referred to the place of myth in art as early as 1920, writing in an article on de Chirico, 'I believe that a veritable modern mythology is in formation'.[13] These words, written while he had yet to abandon his training as a doctor and launch himself as a writer, expressed what was to become the staple theme of Breton's view of myth, that is, myth was interesting for what it expressed about the present, or indeed the future, rather than the past. The symbols of classical mythology had had their day: 'To imagine the sphinx as a lion with a woman's head', he wrote in the same article, 'was once poetic'; but now, he added, paraphrasing one of the fundamental principles of psychoanalysis, anything could be used as a symbol. In 1947 Breton repeated this idea, saying, 'All modern mythology, still in the process of formation, is based ultimately on the work, almost indivisible in spirit, of Alberto Savinio and his brother Giorgio de Chirico'.[14] In the inter War years, however, Breton made no mention of the Italian artists' use of specific classical myths; nor did he draw attention to the role of myth in texts of the period on Masson, Ernst or Dalí. The inference to be drawn perhaps is that either he did not fully approve of these artists' use of myth, or felt that the subject, with all its cultural and political baggage, was not one easily appropriated by Surrealism.

Regardless of Breton's ambivalent attitude, myth became an identifying feature of Surrealism from the early 1930s. The title of the journal *Minotaure*, which from 1933 to 1939 was the main publication associated with the movement, announced this. According to legend, the minotaur was a monster, half-bull, half-human, that devoured human flesh and was kept at the centre of a labyrinth constructed by the master-builder Daedalus. As a symbol of man's untamed instincts, confined by reason but yet still menacing, it expressed perfectly the surrealists' continuing fascination with the unconscious, although it is perhaps typical that Breton had not wanted a title associated with this dark classical myth (he had argued in vain for the title 'L'Age d'Or', after the film by Buñuel and Dalí). More to his

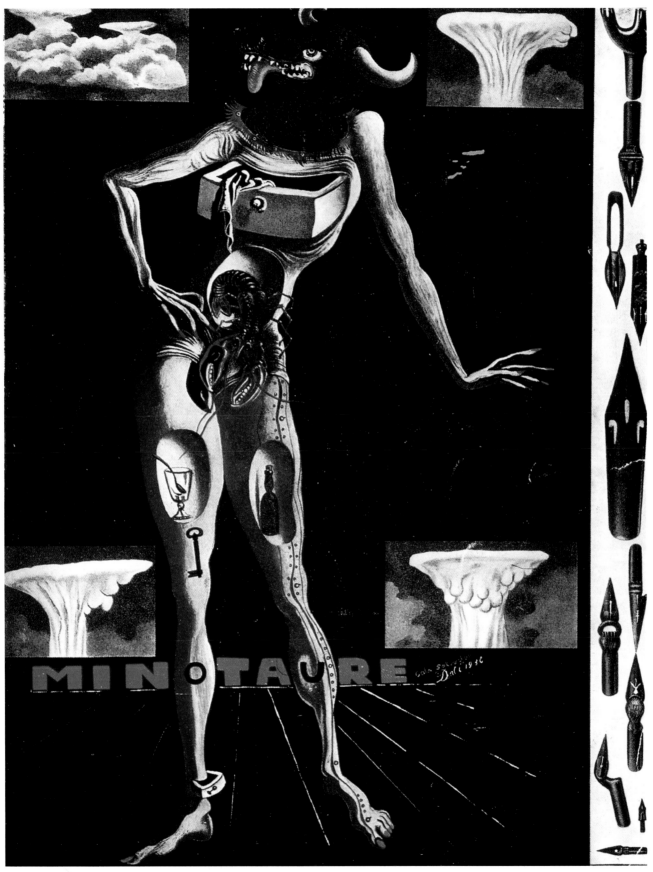

Dalí's design for the cover of the journal *Minotaure*, No 8 1936

taste was the name of the surrealist gallery, Gradiva, established in 1937. The name referred to a figure of an 'advancing woman' on a classical relief, but no homage to the past was intended. *Gradiva: A Pompeian Fantasy* was a novel, written by Wilhelm Jensen in 1903, which had inspired Freud to analyse the psychological mechanisms of the delusions described in the novel in an essay of 1907. For Breton, director of the gallery, the name Gradiva symbolised modern ideas about the workings of the unconscious and the surrealist trope of woman as muse.

Influenced by Freud's investigations into the symbolism of dreams, the surrealists had long prized dreams as evidence of the mysterious powers of the mind to create alternative realities. In the 1930s, however, Freud's assertion that unfulfilled desire was projected individually as dream, and collectively as myth, took on a new resonance as surrealist writers and artists responded to contemporary interest in the subject of myth. In *Mythologie Personelle*, published in 1933, the surrealist writer Maxime Alexandre set out what he saw as the indissoluable relationship between dreams and myth, and its origins in man's childhood.

> We already inherit, together with superstitions going back to the childhood of humanity, a mass of mythological images. Our age also has its myths, to which each individual is more or less susceptible. Each night, in our dreams, we create new myths, or what I shall call personal myths. But what dominates our imagination is this complete and perfect mythological world which was formed during our childhood and which remains the setting of our dreams for all our lives.[15]

The heart of Alexandre's book was given over to accounts of dreams he experienced over a five week period in late 1932. His hope and belief was that readers would be able to subtract the personal, autobiographical elements from this dream journal and find in it general insights into the 'destiny of man'.[16]

The idea of a mythology that was both personal and collective was central to the use of mythological subjects in much surrealist art of the 1930s. Like de Chirico and Ernst before them, Dalí and Picasso used myth as a vehicle with which to explore their own biography; but whereas myth had formerly masked the personal, it was now used to make the personal and strictly autobiographical appear of universal relevance. The classical imagery of Picasso's *Vollard* suite of etchings of 1933, for example, records an arcadian world of art and sensuality; but the focus on the artist and his model, and the subliminal themes of violence and sexuality, hinted strongly at an autobiographical dimension. As one art historian has written, 'One by one and in sequence the prints narrate the movement of an imagination in which characters, suggestively connected with classical mythology, act out new myths,

the surrogates of a multiple and shifting sense of identity, Picasso's own'.[17] With Dalí, the mythic was used to *advertise* the personal. His fraught relationship with his father was a stimulus for his investigation of the William Tell legend; his dependence on his wife Gala the peg on which he hung the Gradiva myth; while *The Metamorphosis of Narcissus* (1937), showcased his theories of paranoiac perception and alluded none too subtly to his own notorious narcissism.

By contrast, Masson rejected this melding of autobiography and myth, and instead developed a mythology of the instincts, presented as inchoate or impersonal forces. 'We note the return to mythological creation', one critic wrote of Masson's work in 1929, 'the return of a psychological archaicism opposed to the archaicism of purely imitative forms.'[18] Masson had earlier sought to explore the normally hidden workings of the mind through automatism, but, abandoning this technique, he now used imagery of flux and metamorphosis (Ovid's *Metamorphoses* was the first important book he remembered reading) to suggest a primal state of beginnings, or, as the reviewer noted, a 'totemic unity' between man and the animal world. Over the course of the 1930s Masson focused increasingly on the themes of eroticism and violence, for which mythological figures served as symbols. Inspired by his reading of Frazer's *The Golden Bough*, Masson produced in 1933, for example, a series of drawings and engravings for which Bataille wrote a text on the subject of 'the gods who die'. The five images, published as *Sacrifices*, were of Orpheus, the Crucified One, Mithra, Osiris and the Minotaur.

Georges Bataille, Surrealism's 'old enemy from within' as he later called himself, was very much a rival to Breton in the early 1930s. A number of former surrealists, including Masson, rejected Breton's authoritarian style, and gathered around Bataille; and following an exchange of colourful insults – Bataille, condemning surrealism as an ineffectual idealism, called Breton a 'castrated lion', while Breton dubbed the former trainee priest 'an obsessive' – the two men did not converse for a period.[19] From 1929 to 1931 Bataille, who earned his living as an archivist and paleographer at the Bibliothèque nationale, was the driving force behind a remarkably heteroclite magazine called *Documents*, which featured learned articles on archaeology, ethnography, sociology and the arts, and combined these with texts and striking images about ordinary or base aspects of life. In the words of one commentator, the magazine offered 'a sort of ethnography of the everyday, in which there was a two-way movement between the exotic and the commonplace'.[20]

With the worsening political climate following Hitler's rise to power in Germany, Bataille and Breton overcame their differences and joined forces in a short-lived anti-fascist (and anti-Stalinist) movement, Contre-Attaque, founded by Bataille in 1935. In this period the

importance of myth and its capacity to define and motivate communities had rarely been clearer. The mass-mobilising fascist movements in Europe were often using folklore and references to legendary, or near legendary, historical events as part of their attempt to define the national community and turn the nation into an object of quasi-religious veneration. In response to this political climate Breton began to re-examine the role of myth in binding society together. In a lecture entitled *Political Position of Today's Art*, given in Prague in 1935, he set out his view that it was the duty of artists to 'abdicate' their own personalities and explore the hidden depths of the mind, in order to discover what he described as the latent collective myth of the age.

Bataille believed in the possibility of creating communities through myth, though he opposed its use by fascists to promote nationalism and racism. After the collapse of Contre-Attaque, he abandoned political activity and focused publicly on fostering interdisciplinary approaches to the study of society. In 1937 he took part in the creation of the Société de Psychologie Collective, which included both anthropologists and psychoanalysts; and with the writers Michel Leiris and Roger Caillois set up the group known as the Collège de Sociologie which brought together some remarkable minds, among them Theodor Adorno and Walter Benjamin.

In the same period, however, Bataille delved more deeply into a Nietzschean vision of life. In the summer of 1936 he founded with Pierre Klossowski and André Masson a magazine titled *Acéphale*, which produced four issues and was the public face of the secret society of the same name. In the opening essay, called *The Sacred Conspiracy*, Bataille drew on Nietzschean ideas to explain the symbolism of the image of the headless figure used on the magazine cover: '*The acephalic man* mythologically expresses sovereignty committed to destruction and the death of God, and in this the identification with the headless man merges and melds with the identification with the superman, which is entirely "the death of God".' Although Bataille did not mention the existence of the secret society, his text hinted at a need to withdraw from the world. 'It is time to abandon the world of the civilised and its light. It is too late to be reasonable and educated, which has led to a life without appeal… Secretly or otherwise, it is necessary to become quite different or to cease to be.'[21] This last phrase echoed some of Breton's more famous pronouncements about Surrealism,[22] and suggests that in setting up the quasi-religious Acéphale sect, Bataille was seeking to imitate Breton's status as the 'pope' of Surrealism, albeit in a non-authoritarian and anti-hierarchical way.

A few months after the meeting of the secret society Acéphale at which Bataille had suggested using human sacrifice, the Germans occupied Paris. A number of those who had worked with Bataille on *Documents* were among the founders of the Resistance. They

Man Ray
Le Minautore 1935

organised a cell based at the Musée de l'Homme and produced a magazine in the museum's basement. The group was betrayed in 1941: its female members were sent to concentration camps and most of the men were shot. In the light of the cataclysmic events that overtook everyone's lives in these years, Bataille's concern to explore through myth alternatives to the constraints of modern society seemed, at best, irrelevant; and Bataille himself later acknowledged as much.

The advent of the Second World War might have been expected to have diminished Surrealism's attachment to myth; but the opposite was true. In part this was perhaps a paradoxical consequence of the sense of dislocation experienced by Breton and the small number of surrealist artists who spent the War years in New York. Living in a 'place that denies myths and sees the world in flat ordinary colours,' as it seemed to another refugee, the writer Anaïs Nin,[23] and separated from the historic centres of Europe, now under threat of destruction, the surrealists were perhaps made more aware than ever of the value of myth in defining the character of a society. In different ways Breton, Ernst and Masson became fascinated by native American myths and the American landscape ('It was in the United States that I began to paint in the way which I ambitiously call chthonic, belonging to the subterranean forces', Masson later wrote. 'I didn't abandon Surrealism but I gave it a new meaning, telluric.'[24]) At the same time, many young American painters saw myth as one of the defining features of the work of the European émigrés, and incorporated references to classical myth in their work.

During the War years the subject of myth was debated more openly than ever before by the surrealists. Eugene Jolas' anthology *Vertical* (1941) included a number of texts from *Acéphale* and a passage from D.H. Lawrence's *Apocalypse* about the need for man to recover a sense of oneness with the cosmos. Jolas himself was much influenced by Bataille's ideas and wrote, 'We are in an epoch of convulsions and blasphemies for the reason that modern man has rejected the universal solidarity of original guilt and lost the sense of liturgy, myth and dream'.[25] As examples of myths that would help modern man rediscover his psychic freedom, he suggested those associated with the idea of ascent: 'astronomic-planetary myths', myths of celestial ascent, including that of Christ, Daedalus and Icarus, and myths of exploration and discovery. Breton was dismissive of both Jolas' and Bataille's vision of myth,[26] but nonetheless made myth the central theme of the 1942 group exhibition, 'The First Papers of Surrealism'. He felt there was a need to promote salutary myths to combat the noxious myths about nations and races that had contributed to the outbreak of War; and in an essay titled *On the Survival of Certain Myths and on Some Other Myths In Growth or Formation*, he listed a number, both old and new, of which he approved. These were 'The Golden Age', Orpheus, Original Sin, Icarus, the Philosophers' Stone, The Grail, Artifical

47 *Christ in Perspective* 1950
Salvador Dalí Museum, Inc., St Petersburg, Florida

Man, Interplanetary Communication, Messiah, Regicide, the Myth of Rimbaud, Superman, the Androgyne, Triumphant Science, and the Great Transparent Ones.

This last myth – which referred to a belief in the possible existence of invisible beings – was prompted by the ideas and paintings of the artists Matta and Gordon Onslow Ford, new recruits to the movement. Breton was keen to promote this myth within the group in place of what he felt were less salutary, darker, and sometimes more violent ones, espoused by Bataille and others. His personal preference was always for light rather than darkness, transparency rather than opacity: in an article on beauty, which was illustrated by photographs of crystalline structures, he once wrote, 'The house I live in, my life, what I write: I dream that these appear from afar in the way that these cubes of rock-salt appear close-to'.[27] It was hardly likely, however, that this would-be myth of the 'Great Transparent Ones' would capture the imagination, let alone the hearts and minds, of a generation that was fighting a World War, and would soon be facing the grim realities of the atomic age and the Cold War.

In the late 1940s, myth remained an important theme within Surrealism, but it was now subsumed into a broader concern with primitive magic, alchemy and the occult. In the 1947 surrealist exhibition held in Paris visitors had to pass through several rooms constituting a kind of spiritual journey or initiation before entering a labyrinth of rooms dedicated to a being, a category of beings or an object 'capable of being endowed with a mythical life'. There were twelve such rooms inspired by fabulous creatures found in favourite surrealist texts, by Breton's 'Great Transparent Ones', and by works of Ernst, Marcel Duchamp and Victor Brauner. Each room had an astrological sign. Missing, however, were references to the mythical figures, classical and otherwise, that had been so prominent in surrealist work of the 1930s.

Bataille, who was now reconciled to the surrealist group, was invited along with a number of other former Acéphale members to contribute to the exhibition catalogue. He used the opportunity to distance himself from some of his former views, proclaiming, through a series of paradoxes, that the time of myths had passed. The post-War age was dominated by an 'absence of myth', he claimed.

> And today, because a myth is dead or is dying, we see through it more easily than if it were alive: it is dearth that perfects transparency, and it is suffering that brings happiness. "The night is also a sun" and the absence of myth is also a myth: the coldest, the purest, the only *true* myth.[28]

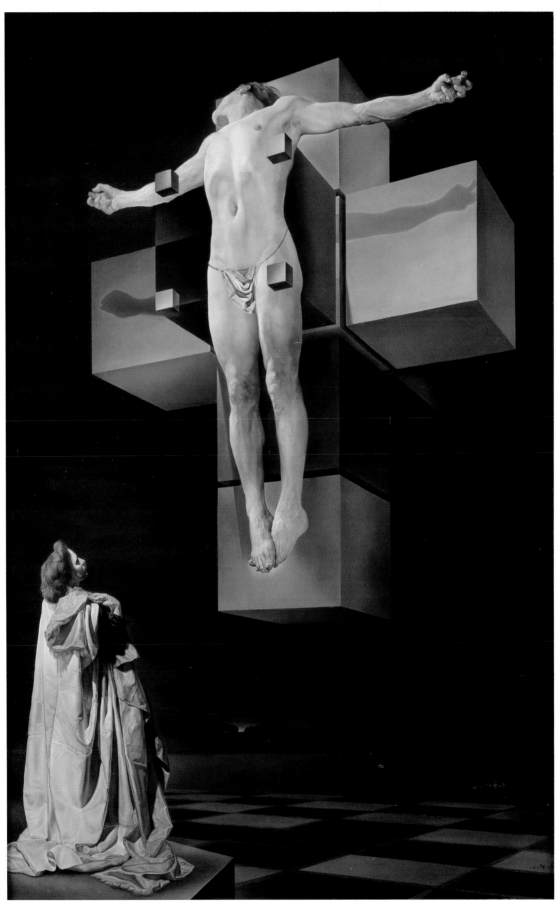

50 *Crucifixion (Corpus Hypercubus)* 1954
Metropolitan Museum of Art, New York

Breton declined to speculate, in the same catalogue, on whether the 'absence of myth' was indeed, as Bataille had suggested, the new modern myth. Instead, he restated his faith in the capacity of art objects to exert a power which could be described as mythic, and which it was up to the surrealists to define.

Henceforth, Surrealism was no longer concerned with the creation or adaption of specific myths. The belief that the desires of the individual were perfectly mirrored and expressed in the myths of the collective – anticipated and rehearsed in different ways so distinctively by Nietzsche, Frazer and Freud – had faded; and myth was no longer perceived, at least within Surrealism, as a potential palliative for the ills of modern society.

Notes

1
Georges Bataille, *Oeuvres Complètes*, Paris 1990, vol.2, p.277–8.

2
Quoted in Alastair Brotchie, 'Introduction', in Georges Bataile, Michel Leiris, Marcel Griaule et al, *Encyclopaedia Acephalica*, London 1995, p.15.

3
Quoted in J.P. Stern, *Nietzsche*, London 1978, p.46–7.

4
Quoted in Walter Kaufmann, 'Translator's Introduction', in Friedrich Nietzsche, *The Birth of Tragedy and The Case of Wagner*, New York 1967, p.8.

5
Sir James Frazer, *The Golden Bough: A Study in Magic and Religion*, abridged edition, London 1923, p.2.

6
G.S. Kirk, *Myth: Its Meaning and Function in Ancient and Other Cultures*, Cambridge 1970, p.3.

7
Laurie Schneider Adams, *Art and Psychoanalysis*, London, 1993, p.2.

8
Sigmund Freud, 'Totem and Taboo', in *The Origins of Religion*, The Pelican Freud Library, Harmondsworth, Middlessex, 1985, vol.13, p.219.

9
Tract signed by twenty-eight members of the surrealist circle including, Aragon, Breton, Ernst, Leiris and Masson. Quoted in Sidra Stich, *Anxious Visions: Surrealist Art*, exh. cat., University Art Museum, Berkeley, 1990, p.15.

10
Quoted in Elizabeth Legge, *Max Ernst: The Psychoanalytic Sources*, Ann Arbor, 1989, p.2.

11
ibid., p.3.

12
William Rubin and Carolyn Lanchner, *André Masson*, exh. cat., Museum of Modern Art, New York, June – Aug. 1976, p.103.

13
'Giorgio de Chirico' in André Breton, *Oeuvres Complètes*, vol.1, Paris 1988, p.250.

14
Quoted in Elizabeth Cowling and Jennifer Mundy, *On Classic Ground: Picasso, Léger, de Chirico and the New Classicism*, exh. cat., Tate Gallery, London, 1990, p.228.

15
Maxime Alexandre, *Mythologie personelle*, Paris 1933, p.12.

16
ibid., p.17.

17
Christopher Green, 'Classicisms of Transcendence and of Transience: Maillol, Picasso and de Chirico', in Cowling and Mundy, p.273.

18
Carl Einstein, 'André Masson, Etude ethnologique', *Documents*, May 1929, p.100.

19
See Michael Richardson, 'Introduction', in Georges Bataille, *The Absence of Myth: Writings on Surrealism*, London and New York 1994, p.5.

20
Michael Richardson, *Georges Bataille*, London and New York 1994, p.52.

21
Georges Bataille, 'La Conjuration sacrée', reprinted in *Acéphale: Religion, sociologie, philosophie 1936–1939*, Paris 1980, p.3.

22
See, for example, Breton's phrase at the end of his novel *Nadja* (1928), 'Beauty will be *convulsive* or will not be'.

23
Quoted in Martica Sawin, *Surrealism in Exile and the Beginning of the New York School*, Cambridge, Massachusetts and London 1995, p.150.

24
Rubin and Lanchner, p.163–4.

25
ed. Eugene Jolas, *Vertical: A Yearbook for Romantic-Mystic Ascensions*, New York 1941, p.11.

26
See 'The Legendary Life of Max Ernst Preceded by a Brief Discussion of the Need For a New Myth', in André Breton, *Surrealism and Painting*, trans. Simon Watson Taylor, London 1972, p.155.

27
André Breton, 'La Beauté sera convulsive', *Minotaure*, no.5, 1934, p.13.

28
Georges Bataille, L'Absense de mythe', *Le Surréalisme en 1947*, exh. cat., Galerie Maeght, Paris 1947, p.65.

List of Works

1

Portrait of the Artist's Father
1925
Oil on canvas
1000 × 1000mm
Museu Nacional d'Art de Catalunya,
Barcelona
(Tate Gallery Liverpool only)
p37

2

Portrait of the Artist's Father and Sister
1925
Pencil on paper
490 × 330mm
Museu Nacional d'Art de Catalunya,
Barcelona
(Salvador Dalí Museum only)
p37

3

Girl with Curls
1926
Oil on panel
508 × 400mm
Salvador Dalí Museum, Inc.,
St Petersburg, Florida
p61

4

The First Days of Spring
1929
Oil on panel
501 × 650mm
Salvador Dalí Museum, Inc.,
St Petersburg, Florida
pp41, 109

5

Phantasmagoria
1929
Oil on panel
690 × 440mm
J. Nicholson, Beverly Hills, California
pp56, 109

6

The Average Bureaucrat
1930
Oil on canvas
810 × 654mm
Salvador Dalí Museum, Inc.,
St Petersburg, Florida
p30

7

The Font
1930
Oil on panel
660 × 413mm
Salvador Dalí Museum, Inc.,
St Petersburg, Florida
pp42, 49

8

Gradiva, Study for 'The Invisible Man'
1930
Ink and pencil on paper
350 × 250mm
Salvador Dalí Museum, Inc.,
St Petersburg, Florida
p60

9

Untitled
1930
Pencil on paper
188 × 149mm
Mme Bénédicte Petit, Paris
p30

10

William Tell and Gradiva
1930
Oil on copper
300 × 240mm
Fundació Gala-Salvador Dalí, Figueres
(Tate Gallery Liverpool only)
p52

11

Gala
1931
Oil and heavy impasto on nacreous
postcard
140 × 91mm
Albert Field, New York
p55

12

*Gradiva Rediscovers the
Anthropomorphic Ruins*
1931
Oil on canvas
650 × 540mm
Fundación Collección
Thyssen-Bornemisza, Madrid
(Tate Gallery Liverpool only)
p63

13

Remorse or *Sphinx Embedded in the
Sand*
1931
Oil on canvas
190 × 267mm
Kresge Art Museum Collection,
Michigan State University, gift of John
F. Wolfram, Michigan
(Tate Gallery Liverpool only)
p65

14

Diurnal Fantasies
1932
Oil on canvas
813 × 1003mm
Salvador Dalí Museum, Inc.,
St Petersburg, Florida
p129

15

Figure after William Tell
1932
Red and black ink on paper
254 × 124mm
Salvador Dalí Museum, Inc.,
St Petersburg, Florida
p34

16

Figure after William Tell
1932
Red and black ink on paper
254 × 146mm
Salvador Dalí Museum, Inc.,
St Petersburg, Florida
p34

17
Memory of the Child-Woman
1932
Oil on canvas
991 × 1200mm
Salvador Dalí Museum, Inc.,
St Petersburg, Florida
pp42, 47, 109

18
Study for 'Meditation on the Harp'
1932–3
Pencil on paper
307 × 207mm
Salvador Dalí Museum, Inc.,
St Petersburg, Florida
p22

19
Meditation on the Harp
1932–4
Oil on canvas
667 × 470mm
Salvador Dalí Museum, Inc.,
St Petersburg, Florida
p23

20
The Architectonic Angelus of Millet
1933
Oil on canvas
730 × 600mm
Museo Nacional Centro de Arte
Reina Sofía, Madrid
p17

21
*The Enigma of William Tell with the
Apparition of a Celestial Gala*
1933
Ink and pencil on paper
172 × 220mm
Salvador Dalí Museum, Inc.,
St Petersburg, Florida
p38

22
*Gala and the Angelus of Millet
Preceding the Imminent Arrival
of the Conic Anamorphoses*
1933
Oil on panel
242 × 192mm
National Gallery of Canada, Ottawa
p31

23
Study for 'Conic Anamorphosis'
1933
Pencil on paper
242 × 178mm
Salvador Dalí Museum, Inc.,
St Petersburg, Florida
p30

24
*Study for 'Portrait of the
Vicomtesse de Noailles'*
1933
Pencil on paper
242 × 172mm
Salvador Dalí Museum, Inc.,
St Petersburg, Florida
p110

25
Sugar Sphinx
1933
Oil on canvas
730 × 597mm
Salvador Dalí Museum, Inc.,
St Petersburg, Florida
p67

26
*Archaeological Reminiscence of
Millet's Angelus*
1933–5
Oil on panel
317 × 394mm
Salvador Dalí Museum, Inc.,
St Petersburg, Florida
front cover, p26

27
Conic Anamorphosis
1934
Ink on paper
293 × 222mm
Salvador Dalí Museum, Inc.,
St Petersburg, Florida
p30

28
Homage to the Angelus of Millet
1934
Ink on paper
184 × 108mm
Salvador Dalí Museum, Inc.,
St Petersburg, Florida
p21

29
Les Chants de Maldoror
1934
44 ink engravings on paper
Each 220 × 165mm
Salvador Dalí Museum, Inc.,
St Petersburg, Florida

30
*Gangsterism and Goofy Visions of
New York*
1935
Pencil on paper
546 × 400mm
The Menil Collection, Houston
p51

31
Couple with their Heads Full of Clouds
1936
Oil on panel
Man: 925 × 695mm
Woman: 820 × 625mm
Museum Boijmans Van Beuningen,
Rotterdam
back cover, p27

32
*Study for 'Metamorphosis of
Narcissus'*
1937
Ink on paper
455 × 420mm
Courtesy of Helly Nahmad Gallery,
London
p91

33
Metamorphosis of Narcissus
1937
Oil on canvas
511 × 781mm
Tate Gallery, London
pp 82–3, 95, 97

34
Untitled
1937
Pencil on paper
255 × 205mm
The Trustees of the Edward James
Foundation
(Tate Gallery Liverpool only)

35
*Debris of an Automobile Giving Birth
to a Blind Horse Biting a Telephone*
1938
Oil on canvas
545 × 651mm
The Museum of Modern Art, New York,
James Thrall Soby Bequest, 1979
p104

36
Mountain Lake
1938
Oil on canvas
730 × 921mm
Tate Gallery, London
p102

37
Gradiva
c. 1939
Ink on paper
420 × 270mm
Fundació Gala-Salvador Dalí, Figueres
p60

38
The Enigma of Hitler
1939
Oil on canvas
950 × 1410mm
Museo Nacional Centro de Arte
Reina Sofía, Madrid
pp122–3

39
Landscape with Telephones in a Dish
1939
Oil on canvas
220 × 300mm
Courtesy Helly Nahmad Gallery,
London
p105

40
Portrait of Sigmund Freud
1939
Ink on blotting paper
350 × 285mm
Freud Museum, London
p79

41
*Telephone in a Dish with Three Grilled
Sardines at the End of September*
1939
Oil on canvas
457 × 551mm
Salvador Dalí Museum, Inc.,
St Petersburg, Florida
p103

42
William Tell Group
1942–3
Pencil on paper
307 × 470mm
Salvador Dalí Museum, Inc.,
St Petersburg, Florida
p34

43
Study for 'Leda Atomica'
1947
Ink on paper
734 × 580mm
Fundació Gala-Salvador Dalí, Figueres
p74

44
Study for 'Leda Atomica'
1947
Etching, drypoint and watercolour on
paper
725 × 573mm
Fundació Gala-Salvador Dalí, Figueres
(Tate Gallery Liverpool only)
p75

45
Study for 'The Madonna of Port Lligat'
1947
Pencil on paper
355 × 282mm
Fundació Gala-Salvador Dalí, Figueres

46
*The Madonna of Port Lligat
(first version)*
1949
Oil on canvas
495 × 380mm
Patrick and Beatrice Haggerty Museum
of Art, Marquette University, Milwaukee,
Wisconsin, U. S. A., Gift of Mr. and
Mrs. Ira Haupt (59.9)
p73

47
Christ in Perspective
1950
Sanguine on paper
762 × 1016mm
Salvador Dalí Museum, Inc.,
St Petersburg, Florida
p139

48
*Study for the Head of 'The Madonna
of Port Lligat'*
1950
Ink and sanguine wash on paper
505 × 314mm
Salvador Dalí Museum, Inc.,
St Petersburg, Florida
p70

49
Gala Madonna
1953
Photograph and mixed media
90 × 75mm
Perrot-Moore Art Centre, Cadaqués
p71

50

Crucifixion (Corpus Hypercubus)
1954
Oil on canvas
1946 × 1242mm
Metropolitan Museum of Art, New York
(Salvador Dalí Museum only)
p141

51

*Portrait of Laurence Olivier in the Role
of Richard III*
1955
Oil on canvas
737 × 630mm
Perrot-Moore Art Centre, Cadaqués
p117

52

Portrait of my Dead Brother
1963
Oil on canvas
1752 × 1752mm
Salvador Dalí Museum, Inc.,
St Petersburg, Florida
p29

53

*Homage to Millet – Study for
'Perpignan Railway Station'*
1965
Coloured pencil on paper
600 × 400mm
Fundació Gala-Salvador Dalí, Figueres
(Tate Gallery Liverpool only)
p19

54

*Perpignan Railway Station
(small version)*
1965
Oil and photograph on paper
200 × 270mm
Perrot-Moore Art Centre, Cadaqués

List of Salvador Dalí works illustrated but not in exhibition

The Great Masturbator
1929
Oil on canvas
1100 × 1505mm
Museo Nacional Centro de Arte
Reina Sofía, Madrid
pp42,107

Illumined Pleasures
1929
Oil and collage on composition board
238 × 377mm
The Museum of Modern Art, New York.
The Sidney and Harriet Janis Collection
pp42, 109, 115

*Imperial Monument to the
Child-Woman*
c. 1929
Oil on canvas
1422 × 812mm
Museo Nacional Centro de Arte
Reina Sofía, Madrid
pp45, 109

The Profanation of the Host
1929
Oil on canvas
1000 × 730mm
Salvador Dali Museum, Inc.,
St Petersburg, Florida
pp42, 53

Frontispiece for 'La femme visible'
1930
Etching after an indian ink drawing
282 × 221mm
Paris Editions Surrealist
p43

William Tell
1930
Oil and collage on canvas
1130 × 870mm
Private Collection
p35

The Birth of Liquid Desires
1931–2
Oil on canvas
961 × 1123mm
Collezione Peggy Guggenheim
p91

Gradiva
1932
Pen and ink on paper
630 × 455mm
Staatliche Graphische Sammlung,
Munich
p60

Portrait of Gala (L'Angélus de Gala)
1935
Oil on wood
324 × 267mm
The Museum of Modern Art, New York.
Gift of Abby Aldrich Rockefeller
p66

Design for the cover of the journal
Minotaure, No 8
1936
p133

Leda Atomica
1949
Oil on canvas
603 × 444mm
Fundació Gala-Salvador Dalí, Figueres
p72

Perpignan Railway Station
1965
Oil on canvas
2950 × 4060mm
Museum Ludwig, Köln
pp2, 25

The Trustees and Director of the Tate Gallery are indebted to the following for their generous support of Tate Gallery Liverpool.

Photo credits

Index

Page numbers in *italics* refer
to illustrations.